MW00657369

Before You Buy This Book ...

Before you buy this book, you might want to try this weird experiment. Think of something you have a major fear of, like Spiders, Snakes, Flying, Public Speaking, etc. or think of something in your past that gives you bad feelings when you remember it now. Rate the discomfort you feel while thinking of it on a scale of one to ten, ten being the worst you can imagine and one being no discomfort at all.

Then, while you continue to think about what bothers you, use just *two fingers* and lightly touch each place on your body shown on the diagram on the following page. Touch each place for about *4 or 5 seconds*. Breathe normally while touching the points in the *exact order* shown by the numbers.

It doesn't matter which side of the face or body you touch. Use either hand to touch each point 1 – 15.

(See diagram on next page)

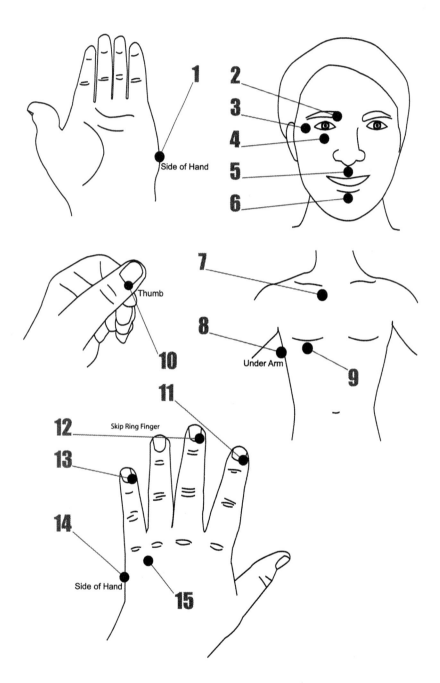

The Happiness Code Sequence

Now continue touching the #15 spot while you:

a. Close your eyes and open them again;

b. Move your eyes down and to the right and then down and to the left;

c. (Still touching #15) Whirl your eyes in a complete circle;

d. Whirl your eyes in the other direction;

e. Stop eye movement, but keep touching #15 and hum a 5-second tune;

f. Count to five out loud (1-2-3-4-5);

g. Hum a tune again.

Now again access the thought that was bothering you when you started the touching sequence. Is the fear gone or lowered on a scale of one-to-ten? Are the feelings about the past issue more comfortable?

If you experienced no change for the better and you are sure you were doing the touching sequence correctly and in the right order, just put the book back on the shelf and have a nice day. For the vast majority of you who did the exercise and noticed a positive change in your feelings, take the book home and find out how and why the "magic" happened. Let me show you how to use this amazing power I call *The Happiness Code* to create your ultimate emotional comfort zone.

Who knows? Looking back on it, you may find that reading this book may have been the two most important hours of your life!

DISCLAIMER

The material provided in this book is for information only, and is not a substitute for any medical advice or treatment.

The author and publisher have taken care in preparation of this book, but make no expressed or implied warranty of any kind and assume no responsibility for any errors or omissions. No liability is assumed for incidental or consequential damages in connection with or arising out of information contained in this book.

The techniques outlined in this book are designed to help you restore emotional balance at times of distress. The author makes no claims with regard to physical healing or to the cure of mental or psychiatric disorders. The methods in this book should not be used in place of proper medical or psychological treatment. If you are having serious physical or emotional problems, it is important that you seek proper professional assessment and treatment.

This book is designed to provide accurate and authoritative information with regard to the subject matter covered herein. It is sold with the clear understanding that the publisher is not engaged in rendering any professional services. If any expert assistance is required, the services of a competent person should be sought.

The Happiness Code

The Amazing New Science of Creating Our Ultimate Emotional Comfort Zone!

Happiness is a journey, not a destination. Travel it without fear and enjoy a more loving, happy, and productive life.

by
Gary L. Laundre, Ph.D.

RICHMOND HOUSE
Salt Lake City

Images in this book have been provided by the following:

Photodisc Red / Getty Images - www.gettyimages.com
Gary Laundre - The American Institute
Lloyd Richmond

Library of Congress Cataloging-in-Publication Data

Laundre, Gary L., 1947-
 The happiness code : the amazing new science of creating our ultimate
emotional comfort zone! / by Gary L. Laundre. -- 1st ed.
 p. cm.
 "Happiness is a journey, not a destination. Travel it without fear and
enjoy a more loving, happy, and productive life."
 Summary: "Through narratives, illustrations, and step-by-step directions,
describes mind-body functions that can cause fear reactions in humans, while
offering therapeutic techniques designed to release anxiety, phobias, panic
attacks, anger, grief, trauma, shame, embarrassment. Includes information
about improving relationships, workplace communication, and business
productivity"--Provided by publisher.
 Includes index.
 ISBN 978-0-9708465-1-8 (trade pbk. : alk. paper)
 1. Happiness. 2. Happiness--Physiological aspects. 3. Mind and body. I.
Title.
 BF575.H27L38 2007
 158--dc22

 2007012595

Printed in the United States of America

Copyright © 2007 Gary L. Laundre
All Rights Reserved
The Happiness Code - The Amazing New Science of Creating
Our Ultimate Emotional Comfort Zone!
ISBN13 978-0-9708465-1-8
ISBN 0-9708465-1-7
Published by Richmond House

First Edition April 2007

Books available through
RICHMOND HOUSE
PO Box 966, Draper, UT 84020
(801) 495-9620

Without limiting the rights under copyright reserved above, no part of this publication may be
reproduced, stored in or introduced into a retrieval system, or transmitted, in any form, or by any means
(electronic, mechanical, photocopying, recording, or otherwise), without the prior written permission
of both the copyright owner and the above publisher of this book.

*Dedicated to Samuel
and all those who came here
because they care.*

"The opposite of love is not hate, it is fear."

Table of Contents

The Happiness Code can set you free –

Major fears or phobias

Panic attacks . 55

Guilt, shame, or embarrassment . 63

Anger . 69

The pain of grief or lost love . 77

Anxiety or depression . 85

Foreword

Over the years since Gary Laundre's last book, "How to Expand Your Comfort Zone" a lot of scientific progress has taken place in the field of brain-body research. It takes dedication and effort for a behavioral therapist to stay abreast of the constant changes in this field. Gary incorporates such knowledge into his investigation and resolution of his clients' problems. For even the most highly-touted regimens he investigates, it doesn't take long for him to realize what really works and what doesn't.

There are many approaches available. Virtually anyone can theorize solutions. Many others simply avoid new technologies and only provide the methods they've used for decades. Then there's the professional who rolls up their sleeves and gets involved finding new, practical, even elegant solutions to today's mental and emotional challenges.

Gary is such a person. Since I first met him over fifteen years ago, I've watched him take on some of the tough cases that some of his industry colleagues avoid. With determination and creative curiosity, he seeks out and finds the tools and the techniques that will solve those tough challenges.

Like others who ultimately make a difference in our society, Gary is one who has a lot of personal integrity. He has a lot of inner strength, and he is committed to helping people. That phrase may seem trite, but in Gary's case, it is the real thing. He really does care.

That may be why his referred client list keeps growing. He doesn't advertise his services. It all comes from people who enjoy a better, more comfortable emotional life because they once walked into his office, or in some other way received help from him.

In this book, Dr. Laundre takes a quantum leap beyond the other practitioners in his field to disclose new findings and logical conclusions about why many of us do not achieve our full potential or happiness in this life. His discoveries have changed my life for the better, and I know many other people who've had similar experiences. So, if you're the least bit curious about what he's been up to recently, read this book and take the advice that he offers. You'll be better for it.

Gary's message is pretty simple. Several years ago, as part of his professional continuing education and research, he discovered a new and simple "exercise" that offers great promise in resolving the thousands of behavioral issues that we deal with everyday. He's used it for years to deal with some of the toughest cases.

Recently, in the course of additional research he discovered something that profoundly affects the rest of us. There is a reason why we have difficulty controlling anger, urges, emotions, and the like. We are physical "collectors" of traumatic information. Our mind-body system stores our memories – facts, experiences, and emotions in a unique way, and virtually all with the original traumatic emotions intact, albeit out of context. Some we are aware of, but most are completely invisible to us. Now, every one of these fiery, reactive memories is vulnerable to being triggered by a common, everyday sight, sound, touch, taste, etc.

So what happens? We're going along happy as can be, doing our own thing, and POW! A word, a sound, an image, will pass by our conscious mind and it will automatically set

off an emotional landmine. Most of us think that our itinerant moments of sadness, fear, jealousy, grief, loneliness, inadequacy, and non-performance are just everyday shifts in our state of being – they are normal. We just tolerate them. We simply act out alternative behaviors until the real us is back.

Well, Gary discovered something extremely valuable to our happiness and well being. He's discovered a simple bio-neural switch that is part of our very makeup, that can easily be used to totally eliminate reactive behavior, even if we don't know where that reactivity is coming from.

In my business life as well as in my social, religious, and family life, I deal with people constantly. In the past I would often find myself resistant to certain people, conversations, transactions, and situations because I was simply "uncomfortable" with them. I'm not talking about reactive feelings that throw my life into turmoil. These are those "boundaries" we all set so that we stay in our comfort zone.

So, with the Happiness Code sequence in my toolkit, I began to systematically eliminate one uncomfortable feeling after another. Gary explains why and how it works here in this book. Soon, it became easier to make pro-active rather than reactive choices. I am calmer now, and less frustrated with change, disappointment, or error – my own or others.

I have a friend who learned that I was using this, and he insisted that I help him overcome a lifelong fear. Now, this guy isn't someone you're likely to meet at the therapist's office. He's a respected educator with years of success in his field. But during all those years, he's carried an emotional time bomb deep inside, and he's "dealt" with it – just like we all do. Anyway, I agreed to teach him this technique.

In less than five minutes, he turned to me and said, "Lloyd, you have saved my life!" Now, you must

understand that this guy is like the Rock of Gibraltar to all of us in his peer group. He doesn't seem to have any emotional problems. But he knew that he was unhappy and suffering because of one. Anyway, I was stunned when he said that to me, and I asked him to explain himself. He described the experience as an emotional wall that had simply dissolved and faded away like a mist in the sunlight. This was dramatic for me, because he literally changed – his face, posture, and expression – right before my eyes.

That experience is just one of hundreds that I've had with other people over the years since I've learned the Happiness Code from Gary. Some changes are seemingly small, some significant, some dramatic. Virtually all of them occur within a very short time frame.

I had a couple invite me to their house to explain it shortly after Gary's first book was published. Now, I'm not an expert – certainly no substitute for Dr. Laundre. But I agreed to share what I knew. After explaining it some, the wife disclosed that she was a Neuro-Linguistic Programmer. That's one of those people who are well trained in the use of language – many times in the form of an affirmation – to slowly change behavior patterns in people.

As a child, her husband (I'll call him Tom) suffered a very traumatic experience. He lived in Idaho on a farm with his parents. They had limited means, so when Tom got deathly sick one day and the local doctor insisted that his dad drive him to the University of Utah medical center for treatment, the concern over cost was pretty high on his father's worry list.

They arrived at the hospital and the specialists examined Tom. Then, with Tom lying alone in the examining room, they went to the next room and the doctor explained to his dad that Tom was very, very sick. The remedy was surgery. Naturally Tom's dad inquired about the cost of treatment,

and when he learned it was astronomical, he reacted with an outburst that would change Tom's life, "Well, I guess we might have to let him die." Now, of course, Tom's dad didn't really mean that. In the next room, however, with the door propped open, the young Tom heard every word. And, he became "permanently" traumatized by it.

Although the medical treatment took place, and Tom returned to his home, be began to suffer from an eating disorder. He ballooned up from a skinny, healthy young boy, to an obese, troubled kid. No one could figure out the problem. Even Tom couldn't believe that it was really tied to that earlier event. After all, he knew his parents loved him. They arranged for treatment and everything! During his entire career, he was grossly overweight.

Well, after 45 years of suffering, and after years and years of NLP sessions, he was still in constant emotional distress. He surmised that this was simply because of his obesity and the social ramifications that went with it. His wife had valiantly tried to help him, using the only drug-free solution she had.

So she turned to him and said, "Tom, why don't you try this." Now, my limited confidence was showing, and I hedged a bit, because even though I had experienced success with others, this seemed like an extreme case to me. But, they insisted. So, I went step-by-step through the exercise, and like Gary trained me to do, I asked him to measure the result. His discomfort had only dropped a notch. Then I remembered Gary's instruction. This is a very thought-specific technique. If it doesn't work with one thought, try another. So that's what I asked him to do.

After changing that one item, we went through the exercise again. When we finished, I looked over at him in anticipation, maybe some doubt. Then, this big guy stood up, walked over to me, threw his arms around me and started

crying! (Now, that was a little uncomfortable.) I discovered a few minutes later that Tom had the same amazing emotional release. His hopelessness, tied to a traumatic event that had happened years before, simply dissolved away. Without my prompting, he described it as a wall that had deflated and disappeared.

Again, this is a pretty dramatic demonstration of the efficacy of this technology. If I had enough room, I could give dozens of additional stories, including some of my own, testifying to the value that the Happiness Code offers.

So, if you're skeptical, that's fine. I began with the same skepticism. I've even had people become angry at me for even suggesting that my experiences were real. These days, however, I realize that any reactive emotion sent towards me isn't an attack on me. It's a plea for help. Since I am less reactive, I handle it better, without guilt. Instead, I can respond with hope. I have a book that I can give my new-found friends and business associates to help them enjoy the same benefits that I know about.

Lloyd Richmond, April 2007

Introduction

*Just think about it. What if you had the power to end
feelings of fear, anger, guilt, shame, the pain of grief
and other traumatic memories in your life and the lives
of others in just minutes?*

That's right. Just push a few buttons and the bad feelings
are gone! Where could the world go with such a power?
Perhaps there would be no war or starvation. Prejudice and
hate might no longer be words in our vocabulary. There
could be love and caring beyond anything ever experienced
by human kind. The light that shines within us all would
rise to its highest frequency of vibration. There could be
truly unconditional love for ourselves and others. We could
celebrate our differences as the beautiful textures of life they
should be. It would be magic!!

When I was a child I wanted to believe in magic. I wanted
to believe in magicians and wizards like Merlin. I even
wanted to be them. In fact part of me believes that in some
past life I was one of them. I also like to think that if I was, I
used my magical powers for the greater good.

Through the millenniums magic (powerful knowledge)
has been taught only to a few select deemed worthy of such
wisdom. After all, knowing how to use and transform
energy from one form to another is not something to be
taken lightly. It was only taught to a few in the strictest of

ancient mystery schools. Mankind at large was not ready for such information. You know – no throwing pearls before swine and all that. As time passed, the keepers of this universal wisdom found fewer students they trusted enough with such powerful information, thus much of it has been lost or at least hidden for centuries.

Whether the powers that make up this universe are thinking that we are finally worthy of this knowledge or it is a last ditch effort to make this world the sacred loving place it was meant to be, the information of transformational change that has been revealed to us in the last twenty or so years (and described in this book) is as powerful as any magic – real or imagined – ever was or could be. Today is an age of awakening. It's the age of remembering just who and what we really are. We are each a small piece of limitless divinity. Now, God has given us one of the most powerful healing and transformational tools ever known. It would seem a terrible shame to just ignore it or throw it away. As in the movie "Bruce Almighty" We've all got the power! Read this book and learn how to use it! Learn how to use the **"Happiness Code"**.

What just happened??!!!
Why do I feel better??!!!

If you tried the touching exercise described in the front of this book, and are still with me, you are probably wondering how and why you feel more comfortable when you bring back the thought you were thinking during the touch sequence. You might even be trying to get those uncomfortable feelings back just to prove to yourself that you're not in the "Twilight Zone".

Many times when I ask a client how they feel after the touch sequence, their response is, "I can't think of it anymore." But it's not that they can't think about the issue, they just don't get the bad feelings they are used to getting when they think the thought.

You might now be thinking, "Ok, if I'm not just fooling myself and the change I feel is real and lasting, why have I never heard of this **'Happiness Code'** (sometimes referred to as Thought Field Therapy – TFT, Emotional Freedom Technique – EFT, or Mind Tuning) before now?" Well, first of all, this technique has a reported 80 to 90 percent success rate. If you were just fooling yourself or what could be called the placebo effect; it would have no more than an 8% success rate. It's also known that for the placebo effect to happen there must be some pre-expectation or belief that the chosen method of treatment will work. Did you believe it would work? You were probably just hoping no one saw you doing it.

You may remember that during the exercise I asked you to think of something that bothers you emotionally and touch various points on your body in a specific order or code sequence. It was originally thought that it was necessary to tap five to seven times on each of the points, which does work fine, but it has since been discovered that just touching each point for about four or five seconds works just as well and is certainly more comfortable for most people.

These touching points on our body are called *energy meridians*. Basically they are just intersections of major electrical activity in our mind-body system. Think of them as keys on a computer keyboard. Physical practitioners that use acupuncture, acupressure, kinesiology and even masters of martial arts have known them for thousands of years. Up until recently these energy meridians were assumed to only affect humans on a physical level. It has since been discovered that these points also have a huge effect on our emotional well-being. To me, this is the most important discovery in the history of psychotherapy.

As to why you may not have heard about this before, well, it flies in the face of everything most traditionally-trained therapists are ever taught. When you tell someone that the methods they spent so many years studying are as outmoded as the middle-ages practice of bleeding someone has become in medicine, they tend to resist and close their minds to it. Also this technique works very fast. The financial world of talk therapy is not set up for fast. And, if the drug industry can keep us on anxiety medication long term – Cha-Ching $$$!!! Finally, since most of the information on this technique has been introduced mainly to therapists, unless you've been in therapy recently with a progressive thinking therapist, there would have been no way to get the information.

To give you an idea of how dramatic the differences between using the Happiness Code and traditional therapy

methods are, let's use the example of a simple phobia. Suppose a person had a fear of snakes. Traditionally trained therapists would use a technique called systematic desensitization. Over *several sessions* and *many dollars* they would push you close to the thing you're afraid of until you are on the brink of terror and then pull you back away from it. Then do it again and again and again. Fun, huh?

They even have computer virtual reality programs so you can experience your fear over and over without ever leaving the office. How nice! Basically all this type of treatment does is help you stand more pain than you thought you could. Sometimes it makes the fear worse. But with The Happiness Code the terrible fear can be gone in just minutes, and in most cases stay gone.

WHERE THE HAPPINESS CODE CAME FROM

The 20th century saw many positive inroads in the advancement of mind-body medicine. People like Milton Erickson made great advances with the hypnotic techniques of guided imagery or creative visualization. Great insights to the power of the mind were brought to light by the pioneers of positive thinking, Norman Vincent Peale, Napoleon Hill, Earl Nightengale and others.

Then new techniques like NLP (neurolinguistic programming) and EMDR (eye movement desensitization and reprocessing) came on the scene with promising results. These techniques of the past, given enough time, have some positive affects on our negativity and fear. But, they are time-consuming and for the most part quite difficult to self-actuate without considerable training.

Then Dr. Roger Callahan came along with his expertise in psychotherapy and strong knowledge of Kinesiology. He recognized a finite connection, through bio-energy systems,

between human *psychology* and human *physiology*. He discovered how dramatically our physical bodies are impacted by our thought patterns and how our thought patterns are affected by the "keyboard" of the human body known as energy meridians. Dr. Callahan found that if a person lightly taps on certain energy meridians on their body while holding a thought in their mind that had previously caused them emotional upset, the emotional upset would disappear.

Had the great success of his discovery not been such a threat to traditional psycho-therapy, Dr. Roger Callahan might have been nominated for a Nobel Prize.

Over the years he developed many different tapping sequences, or let's call them *codes*, to alleviate various emotional upsets such as fear, anger, guilt, depression and so on. His discovery was first called the Callahan Technique and later became known as TFT (thought field therapy). I think that had the great success of his discovery not been such a threat to traditional psychotherapy, Dr. Roger Callahan might have been nominated for a Nobel Prize.

The problem with TFT's use of different code sequences for different types of emotional upsets was just that, too many different codes. On top of that, if none of the codes worked for a person, then a series of diagnostic muscle tests were necessary to determine the correct code. The good news was that the standard codes worked for most people when the proper code was finally determined. The bad news was that in some cases a lot of time was wasted and some people became discouraged and stopped before the proper code sequence was found. Don't get me wrong, even with these draw backs it was still leaps and bounds beyond anything else available at the time. I am thankful for the great training I

received from Callahan in the use of his techniques. The fees he charged for that training were quite reasonable.

However I was very disappointed in Dr. Callahan's choice to charge what I think is an outrageous fee of one-hundred thousand dollars to train someone in what he called "voice technology." Supposedly, with voice technology, a person only had to speak into a microphone and then an electronic device would interpret for the therapist the code sequence that was necessary to fix the emotional upset of that person. Think of the possibilities – you could help people over the phone.

I wanted it bad, but at a hundred thousand dollars it was out of my league. I could see such a cost if the equipment necessary had to be invented and manufactured for this purpose, but I was told anyone could buy the necessary equipment at Radio Shack. Plus, if you took the $100,000 training, you had to sign an ironclad contract that said you will never ever reveal the secret of "Voice Technology" to anyone else. To me it seemed as outrageous as discovering the cure for cancer and only giving it to millionaires.

But, as it turns out, I'm now very glad that I never scraped together the hundred thousand because a few years later an angel appeared in the form of a man by the name of Gary Craig. Gary Craig was, as I had been, a student of Callahan. The difference is that Gary paid the money to learn the secret of TFT voice technology. Let's just say he was not impressed! He discovered that the results were not as accurate as he had been led to believe they would be, and the technology had very little if anything to do with a person's voice. This led him to challenge the voice technology theory. He then worked to create his own algorithm which evolved into what he now calls EFT (emotional freedom technique). The really great news is that it works as good or better than the $100,000 dollar voice technology.

HOW DOES THE HAPPINESS CODE WORK?

Our brains and bodies are run with electricity. That's correct; brain activity is a series of electrically-coded impulses carried by specialized cells called neurons, of which there are about 100 billion in the brain. I could talk more about neurons and their attached dendrites and axons and how they connect across synapses through chemicals known as neurotransmitters or about quantum theory and microtubules but I can see that yawn coming on your face already. The good news is, you don't need to know any of that stuff to make your life a happier place to be. You only need the right code – The Happiness Code.

> *We are all electrochemical machines. Every thought we have is an electrical impulse.*

But, for those who would like to have a sense of how it works, here's a very basic explanation. Humans are run by electricity. That's right we are all electrochemical machines. Every thought we have is an electrical impulse. Every movement we make is triggered by our electrical thought patterns both conscious and unconscious.

Hold your hand in front of you and move your fingers. (Oh, go ahead. No one's looking.) To make those fingers move, requires electrical impulses from the brain to move through the nervous system to the muscles. Every thought we have is an electrical pattern in the brain *specific* to that thought. In other words to create the same electrical pattern in the brain we must think the same thought.

When we think of something that is emotionally upsetting, the bad feelings of fear, anger, anxiety, and pain are caused by surges (or you could say big spikes) popping up in the electrical thought field of your brain. It is these surges or spikes that trigger our fight or flight system, adrenalin begins

pumping, our heart rate increases and muscles tense. Basically, as the alarms are going off, our system is preparing us to repel an attack or run away from one.

This *fight-or-flight* system worked better for prehistoric cave people than it does for modern society. In the days of the caveman when the main threats were being stepped on by a wooly mammoth or becoming lunch for a saber tooth tiger, the fight or flight response was a welcome guest. But, in modern society with so much input and so many complicated interactions with others, our fight or flight responses are causing chaos in our lives and the world. We have become so fearful of life that we are in high anxiety (fight response) or in depression (flight response) on a daily basis.

Millions of people are being prescribed various drugs in an attempt to dampen the brain's response to these perceived threats. (Good for the drug companies bad for us.) In effect the drugs just mask the symptoms; they don't fix the problem and may also have unwelcome side effects.

The Happiness Code can help to balance the brain's electrical response to a thought pattern that it once interpreted as a threat. With no more spikes or surges in the electrical thought field the problem is eliminated (bad for the drug companies, good for us.)

I'm not saying that if you are currently on some anxiety medication prescribed by a doctor that you should just dump it and use the Happiness Code. But, you can begin using the Happiness Code and discuss with your doctor the possibility of cutting down on your medication gradually under their supervision. The Happiness Code should not be used to replace needed therapy by a licensed professional and is certainly not intended for self-help by anyone suffering from a psychotic disorder.

It is important to note that I have seen people so shocked by a trauma – their mind-body electrical systems so overwhelmed – that they can't hold a thought in their mind long enough to use The Happiness Code effectively. This is certainly an example of someone who could be helped at least temporarily by anxiety medication under medical supervision. Once they are more stabilized they could be directed to use The Happiness Code to eliminate the cause of the problem and possibly reduce or eliminate the need for long term medication. Why just control the fear or upset feelings if you can eliminate them altogether? Drugs do have a place in mental health but we need to move away from the blatant over use of them we see today.

WHAT WE THINK AFFECTS US PHYSICALLY

Practitioners of Kinesiology have known for many years that common, everyday physical items we come in contact with have a major effect on our body's energy system. There is a simple muscle test that has been used by Kinesiologists for many years to determine the body's energy reactions to physical toxins. (You should avoid doing this demonstration if you have a bad back or other arm or shoulder injury.) An e n l i g h t e n i n g demonstration of how physical toxins affect our bodies is simple to do. *(See illustration)*

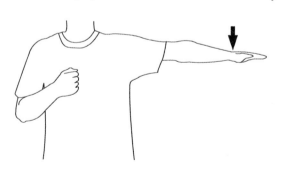

Testing For Toxins (Muscle Test)

Have someone hold one arm out straight sideways keeping it stiff, and hold the other hand touching the chest near the solar plexus. Push down on the extended arm firmly

at the wrist and it should remain strong and stiff. Now place a packet of artificial sweetener, either the pink, blue or yellow packet, into the hand touching the chest and push down on the extended arm once again. With few exceptions the extended arm will test weak.

This shows that chemicals used in these products are toxic to the energy system. I'll leave it up to you as to whether you want to have these chemicals in your body or not. Personally, I never knowingly eat or drink anything sweetened with these products. Your muscle will test weak for anything that is bad for your energy system. If you have an allergy to wheat, holding a piece of wheat bread in your hand touching the chest will cause the extended arm to test weak.

It has only been recently discovered that thoughts which evoke negative emotional responses are just as toxic to our energy system. What we *think* affects us on a physical level. When we think thoughts that upset us our energy system is compromised. Yes, we weaken our energy system when we think negative thoughts. You can see this for yourself by doing a simple demonstration I show all of my clients. (Once again, you should avoid doing this demonstration if you have a bad back or other arm or shoulder injury.)

While thinking something you think is wonderful, hold one of your arms straight out sideways and keep it stiff while someone pushes down on your arm firmly at the wrist with their hand. It should be fairly easy for you to resist the pressure. Now, while thinking of something you consider awful, have the person push down again. Your arm will weaken and may even collapse altogether. It is the best demonstration of how your thought patterns affect your body that I've ever seen.

When we think comfortable thoughts our energy system supports them. When we think negative thoughts, those thoughts are toxic to our energy system and weaken it.

More medical doctors are agreeing that unresolved emotional issues play a strong role in the cause and severity of many physical illnesses.

When we think something, past, present or future, that causes emotional upset, electrical spikes or surges in the thought field automatically trigger alarms in our mind-body system. In effect, the Happiness Code shuts off the alarms and no longer recognizes the thought pattern as a threat. It is not yet fully understood why or what is happening to facilitate such instant and dramatic changes. Some researchers speculate that the process of stimulating certain energy meridians on the body in a specific sequence or code, while thinking an upsetting thought, filters or removes the spikes or surges in the electrical thought field, thus no longer triggering the alarms. Some think that the process sends a safety signal to the brain that neutralizes the old fear signal.

Research funded by the National Institute of Mental Health seems to support the later theory. Their research reported in November 7, 2002, Nature; stated that rats normally freeze with fear when they hear a tone they have been conditioned to associate with an electric shock. Dr. Gregory Quirk and Mohammed Milad, Ponce School of Medicine, Puerto Rico, demonstrated that electrically stimulating a site in the front part of the brain, the prefrontal cortex, extinguishes this fear response by mimicking the brain's own "safety signal." Since the prefrontal cortex is known to project to the amygdala, a hub of fear memory deep in the brain, the researchers propose that increased activity of infralimbic neurons in the prefrontal cortex strengthens memory of safety by inhibiting the amygdala's memory of fear. They speculate that stimulating parts of the prefrontal cortex in anxiety disorder patients, using and experimental technique called transcranial magnetic stimulation, might help control fear.

Personally I don't really care if pushing a few keys on the body's keyboard while accessing a troubled thought, erases an alarm causing spike in the brain's electrical pattern, or sends a safety signal that over rides the old alarm signal. As long as it produces such dramatic and lasting results, who cares?

"Perception: From 'nowhere' to 'now here' is
just a matter of spacing."

Why Are We So Stressed, Anxious, and Fearful?

PAST PAIN CAUSES PRESENT FEAR

Perception is 100% of the law. How we look at the world and ourselves in it, our confidence and self-worth is determined by our past. We are all suffering from our past traumas. Our present attitudes toward life are determined by our past experiences. Our early beliefs are taught and conditioned into us by others. We might be told to look out for the monster under the bed or maybe the boogieman will get us. So now our beliefs trigger our fears. How many kids need the lights on in their bedrooms when they go to sleep? As children we develop fear, guilt, anger, and shame that we hold on to for the rest of our lives. Since children have fewer coping skills, they more often interpret as threats, events that might mean very little to adults. Many times children of divorce blame themselves for their parents' break up. Just think of the guilt, anger at themselves, and low self-image they may have for the rest of their lives. **It's real pain based on a false belief.**

Our fears are formed by our beliefs and our beliefs are formed by our fears.

We are often taught that a person of a certain skin color, religion or political party is something to be feared. When we react to life and to others defensively, it triggers a defensive reaction in others; we get

caught in a loop. Our fears are formed by our beliefs and our beliefs are formed by our fears. In my opinion, if we are going to be afraid of anything it should be our beliefs because many of them are based on pure elephant poop!! We need to examine our beliefs and if they don't allow for unconditional love, tolerance, understanding, compassion, and forgiveness for ourselves and others then maybe it's time to question the source of those beliefs.

Most of our reactive behavior in life comes from perceived traumas in our past. I say perceived traumas because how we think, see or feel about something is based on our own personal perception of the event at the time. And even that perception is based on past events. One person may interpret something as a threat while another person isn't bothered by that issue at all. If we feel anxious or nervous about something today, it is due to our mind's interpretation of past events that were perceived as a threat. In other words, our anxiety today is based upon our past. Everyone on the planet is suffering from a form of *Post-Traumatic Stress Disorder.* That's right, everyone!

Now most people aren't labeled that way unless they are freaked out war veterans up in a bell tower with a rifle, picking off citizens as they walk by, but it is the same thing. It's just that it manifests itself differently in each individual. If someone named Bertha kicked our dog when we were little, we may react negatively to any other person with the name Bertha from that moment on. We might not even consciously remember why we hate that name, we just do. (No offence to anyone named Bertha.) It's also important to realize that since it is a non-analytical process, from that time on, our mind may associate other things that were in the location of the problem as part of the issue. Maybe we'll associate the kind of day it was, sunny, overcast, raining, snowing; perhaps a smell that was in the air or a song that was playing in the background. And from that time on,

anytime any of those elements show up in our lives we react to protect ourselves.

In other words, if today we perceive something as a threat physically or emotionally, part of our mind will now log it away in a file with an alarm signal attached to it. So when something comes along in our life that on some level reminds us consciously or subconsciously of that past issue, the alarm goes off and we become defensive. Our *fight-or-flight* trigger is activated and we become angry or nervous. Our nervous response then triggers other people's alarms. Rational thought flies out the window, and we become very good at pointing fingers at each other while justifying our negative thoughts and behaviors.

When our survival instincts are based on fear instead of love, understanding and tolerance, it's no wonder humans are at war in so many parts of the world. In fact it's easy to see why we are at war in so many parts of our own lives – at work, in our family lives, and in our relationships. There is no fear in HAPPY. Happiness is found by building bridges to each other, not walls between each other.

> *Happiness is found by building bridges to each other, not walls between each other.*

PAST PAIN, FUTURE FEAR

It is also important to understand that it's not just our anxiety about the present that is caused by our past traumas but also our anxiety about the future. All of those "what ifs" that cause us such sleepless nights are really products of our past. What if she says this? What if he doesn't like that? What if I don't know all the answers? What if I'm under dressed? What if they don't like me? What if I don't like them? What if I don't get the job? What if they offer me the

job? And ever on and on it goes. We fear tomorrow because of what happened yesterday. I call this future fear, **PRE-TRAUMATIC STRESS DISORDER**.

So, *pre*-traumatic stress is actually caused by post-traumatic stress. We are reacting in fear to imaginary threats. It hasn't even happened, and probably won't happen. But we react as if it is happening. The funny thing is, since only about five percent of the things we worry about actually happen, and since we usually do manage to handle the things that do happen better than we thought we could, it seems like such a waste of energy to be so afraid of tomorrow.

Think about how our past shapes our future. Let's say we just came out of a relationship that went bad. Maybe we trusted someone to be faithful and they cheated on us. In fact, maybe they had been doing so for quite some time while still telling us how we were the only one. That kind of betrayal can be a lasting trauma of hurt, anger, and grief. People tell us that in time we'll get better. The pain will subside and we will go on with our lives.

But does the pain really get better or do we just get accustomed to it? It becomes part of who we are. We now look at the world through the eyes of pain and mistrust. We sometimes convince ourselves that it's naïve to trust anyone in a relationship. So we may avoid committing to new relationships. Or when we find ourselves in a new relationship, we are extra wary, jealous, and angry when our new partner smiles at or shows any attention to others, no matter how innocent the encounter really was. It is like someone just stepped on a landmine that we once buried for our protection. But like many such mines, sometimes innocent people get blown up by wandering unaware into the minefield. We treat new people that come into our lives as if they are guilty of a crime that, in reality, someone else

committed. We might often act out some sort of drama to test the limits of their love and loyalty.

One of the consequences of such behavior is that it can drive our new partner away or even push them toward the very behaviors we fear by creating an accusatory, uncomfortable environment at home. Another reaction to the same situation might be that we become a human doormat. Our self-esteem becomes so low that we let others take over our lives, afraid that they will leave us if we don't bow to their every whim. We lose our self-respect and the respect of others while attracting users and losers into our lives. That's a couple of examples of how our past pain creates present and future pain, but the list is endless.

We have all had things happen in our lives that were traumatic both emotionally and physically. Maybe it was falling out of a tree and breaking an arm or losing in love and breaking our heart. It may have been a time we were being emotionally, physically or sexually abused. We may have been told we were stupid and would never measure up. Maybe someone ridiculed us about our physical appearance. We may have suffered the loss of a loved one, either human or animal. Any number of uncomfortable experiences we've had as we moved through this exercise in creativity we call life, can trigger a negative reaction in our present or future lives. They become trip wires just waiting for someone or something to come along and trigger our defenses.

These emotional traumas cause what I call **"Invisible Self-Limiting Conflicts."** As the conflicts pile up our emotional comfort zone begins to shrink. Soon, it takes less and less to tick us off or to make us anxious. Our brain chemistry then changes to support a perceived threat and we live in constant anxiety or depression. How can any of us be truly comfortable and happy as long as the demons from our past haunt the dark shadows of our minds?

HOW BIG DO TRAUMAS HAVE TO BE TO HAVE AN EFFECT ON OUR PRESENT BEHAVIOR?

The answer is, not very big. Like all of us, as a child I experienced many emotionally upsetting times. Looking back on some of these events I wonder how I ever got through them. I can easily understand why they left deep emotional scars, but some of them make me think, "Oh come on, why did I let that bother me so much?" The good news is, by using The Happiness Code, an upset can easily be dissolved forever without self-judgment or the need to understand why it mattered so much at the time it happened. In other words, the issue doesn't really have to be resolved in order for its effects to be dissolved.

Remember, what the trauma was is not as important as how it affected us. If it seemed like a big deal when it happened, then somewhere in the archives of our mind it probably still is a big deal and needs to be dissolved. Even small traumas can become layered and thus compound through time.

NOT ALL TRAUMAS THAT AFFECT US ACTUALLY HAPPENED TO US.

Sometimes the traumas we log away in our subconscious are based on other people's stories, real or just made up. Maybe we see something happen to someone else. Let's say a person sees someone who did poorly giving a speech. They may have heard the person being ridiculed by others or even participated in the ridiculing themselves. This person now goes on with life hardly giving the event a second conscious thought, but the subconscious mind now associates the idea of public speaking with the threat of being ridiculed. So now when they are called upon to stand up in front of others to speak, the alarm bells are going off signaling, "Run away, run away!"

Even though the trauma of ridicule never happened to them personally, the "what ifs" now become the threat. It's another example of *pre-traumatic stress disorder*. They react in fear to something that hasn't even happened. Incidentally the fear of public speaking (glossophobia) is one of the most common fears in modern society today. Another example of catching a fear from someone else might be, if a parent with arachnophobia (fear of spiders) enters a room with their small child and upon seeing a spider screams with horror and runs from the room. That child may now be so traumatized by their parent's reaction that they develop that same phobia of spiders.

> *Pre-Traumatic Stress is reacting in fear to something that hasn't even happened.*

We often think it's funny to traumatize others. I used to delight in lying in the shadows and suddenly jumping out in front of my brother to scare the bazooties out of him. It was just a power trip on my part. I was as insecure as the next kid and any little show of power, no matter how fleeting, gave me a perverse sense of security.

Why was I so insecure in the first place? Well, like all of us, as children we have very few coping skills. The ones we do learn, even though they might seem right for the time and environment of youth, don't translate well into our adult lives. We're taught the technique of crushing someone else's self esteem so we can feel better about our own fear-saturated lives. What child hasn't been subjected to it? "Let's get the fat kid, the red head, the tall one, the short one, the smart one, the pretty one, the black one, white one, Latino or Asian one." Even if we didn't participate in the event, just watching it created a fear of being different.

Just think of the things we do to fit in and project an image that will be accepted by our peers. We poke holes in

our bodies and hang things from them. We write things indelibly on our skin. We do all sorts of interesting things because acceptance makes us feel more emotionally secure. The need to be accepted is huge in humans, even to the point of ridiculing others that don't fit a group's self-made image of normal.

> *When we learn our perceptions of life from emotionally damaged adults how can we expect to be anything but damaged ourselves?*

When we learn our perceptions of life from emotionally damaged adults how can we expect to be anything but damaged ourselves? When our lives are built on a foundation of fear we begin to rationalize our actions at the expense of others. We choose to ignore the spiritual truths like, "Do unto others as you would have them do unto you." We begin to bend our own moral standards with mind-crippling thoughts like, "do unto others before they do it to you," or "it's a dog-eat-dog world out there so every man for himself!"

Where did it ever say "I'll only be nice to you as long as you are nice to me"? Why are we afraid to make eye contact with strangers we pass on the street or walk by in the supermarket? Why do we feel our space is being invaded when someone we don't know talks to us while we wait in line? Why do we feel so threatened that we need to speed up to prevent another car from merging into the highway lane in front of us? Why do we blame everything and everyone else for our own emotional discomfort?

The reason humans want control is to feel safe. It's about personal power. We seek control by having power over something or someone, but seeking control of others is like holding onto a bottle of the volatile explosive nitroglycerin. We may have a powerful force in our hands, but it's a destructive force and will only push those we wish

to control to seek a bigger bottle of their own. Trying to control others through fear and intimidation only breeds hostility and contempt. Anytime we feel a need to emotionally or physically injure another living creature it's really our own fear producing a need to feel powerful.

The energy we put out into the world is the energy we get back. It is that simple! So, we need to stop trying to change "that" and instead, start changing ourselves. Let's stop reacting to life and start responding to it. A reaction is triggered without conscious thought involved, yet a response indicates conscious choice.

Let's quit trying to change someone else's behavior and start changing the way we respond to it. It needs to be done at home, in the work place, and with our friends. "Turn the other cheek" doesn't mean to stand there and let someone beat us up. It means to have some empathy for the other person's point of view. Let's try to put ourselves in their shoes and understand why they feel so threatened by us that they want to smack us in the first place. It might be our own judgmental defensive posture that is triggering their defenses.

LESS FEAR, MORE COMMUNICATION

Not to long ago I knew I was going to be involved in what can be described as an extremely adversarial meeting. There is no need to go into the details of the meeting, but let's just say myself and the other parties involved were not on the same page when it came to a certain situation. Heck, not only were we not on the same page, we weren't even in the same book. I remember feeling anxiety about going to the approaching meeting. So I said to myself, "Self, why are you letting this thought of going to the meeting bother you? You have a tool that can make you more comfortable, why not use it?

Then I focused my thoughts on going to the meeting and acknowledged how nervous the thought made me. I went through the Happiness Code sequence while thinking of the up coming meeting. I soon found that the general idea of the meeting no longer bothered me but now my thoughts went to very specific aspects of the meeting that triggered my defensive buttons. First of all I knew the other people that would be participating in the meeting and from past experience I also knew that one of the tactics they might use would be loud threats and red faced table pounding to get what they wanted through bullying and intimidation. I could see and hear it all happening in my mind and the thought of it made me angry and defensive.

I was doing the "what ifs." None of it had even happened yet, but there I was reacting as if it had. So, I decided to take each "what if" separately and run through the Happiness Code sequence while focused on the thought of each one actually happening – including the possibility of not getting anything I wanted out of the meeting. I repeated the sequence for every one of my "what ifs" until the thought of them happening no longer bothered me at all. In fact, when I now thought of the loud red face ranting and pounding, I had to fight back a chuckle.

To make a long boring story a shorter boring story, I went to the meeting feeling quite comfortable. And as usual many of the "what ifs" I had conjured up never happened – but some of them did. The meeting started with me stating my point of view on the issues at hand which triggered a loud red-faced table pounding response from the other side.

The interesting part is that the actual event didn't really bother me at all. And because I wasn't reacting defensively I was able to really listen and understand why this person had such a different point of view. Instead of wanting to yell, "OH YEAH, THAT'S WHAT YOU THINK YOU LOUD MOUTH IGNORAMUS!," I was able to calmly state that he had made some very good points and that I thought I now understood some of his concerns.

It was like something had just sucked all the negative energy out of the room. Every voice reduced volume to a civil level and real communication began. I ran the show simply because I was the only truly comfortable person in the room. (Remember, the energy we project in life is always reflected back at us.) I didn't try to change them. I only changed me! And as a result the meeting turned into a "win-win" situation.

> *Remember, the energy we project in life is always reflected back at us.*

THINGS WILL NEVER CHANGE IF WE DON'T

Hopefully by now you're getting the idea that "THEY" are not the cause of our anxieties but rather it's our own reactive fear based thought patterns, caused by the way we have processed past events, that are mucking up the water.

It always seems to be so much easier to blame "THEM" for everything. After all it's not our fault – we're the victim here, right? Well if we want to maintain and amplify our stress levels in life, the best and most sure-fire way is through the victim mentality of, "If only *they* would change then everything would be okay." Well the bad news is, if we stay the same, they probably won't change either, because when we just *react* in fear, which shows up as judgment, intolerance and anger, then others will react in a defensive

manner. But, if we choose not to let those buttons get pushed and we respond to the situation with the more comfortable emotions of empathy, understanding and tolerance, then they will react differently, even if they are still just reacting. So by changing us we change them. By projecting the power of love and respect we breed love and respect.

The Happiness Code can set you free –

DISCONNECTING THE BUTTONS

We've all heard people say, "They are always pushing my buttons," which is just another, "I have no control over my emotions" victim statement. "He or she makes me so mad," is another example. It's easier to blame others for our choices that don't turn out the way we want rather than to accept the fact that we make the choices that rule our lives. Even if we choose to give others the power to choose for us, it is still our choice to do so. How can we ever expect to be happy if we always give someone else power over our feelings? When we absolve ourselves of the responsibility of choice we feel out of control and that leads to anger, fear, anxiety and depression.

God gave us free will to act out of love and create miracles, or choose fear and create misery. We are powerful beings. We are so powerful that when we choose to act out of fear, we can mess up even the best of circumstances. However, when we choose to act out of love, we can change the world in wonderful ways. Using The Happiness Code can open the vault to "Possibility Thinking", or "Magical Thinking" where our dreams can actually come true. It allows us to color outside the lines and experience this exercise in creativity we call life at a higher level of consciousness. True nobility is not being better than anyone else. It is being better than we used to be.

So how do we go about taking back control of our emotions? Well, we can ruin someone else's day by venting our emotional frustration at them. Of course they will then give us advice we don't want to hear because we really don't want to fix anything. We just want to justify our feelings. We want to hear that we have a right to wallow in our self-righteous misery. Unfortunately *it seems to be true that misery loves company, but it's also true that company very seldom loves misery*. That's why you often hear others say things like "Oh come on – why let it bother you so much? It's no big deal. Just look at it like this and you will feel fine"? But as we know, that's easy for them to say, but hard, if not impossible, to do when our instant reaction to the situation, is a feeling of anger, fear, guilt, grief, anxiety or depression. Our reaction was "unfixable," at least until the Happiness Code came along. Now we can dissolve the bonds of negative emotions and quit just *reacting* to life and start choosing the way we want to *respond* to life. We need to stop confusing our "drama" for passion. *When we change the way we look at things, the things we look at change*.

USING THE HAPPINESS CODE – WHAT IT CAN DO TO CHANGE OUR LIVES

The Happiness Code can be used to eliminate or significantly reduce the negative effects of past traumas, feelings of fear, anxiety, phobias, panic attacks, anger, grief, shame, guilt, embarrassment, depression, addictive urges and obsessive behavior. It has also been reported to reduce or eliminate some forms of physical pain, and is sometimes effective in reducing or eliminating inhalant type allergy reactions.

My advice is, if something is bothering you emotionally or physically, try the Happiness Code on it and see what

happens. There is no downside to it. If you use it incorrectly you won't get better, but you won't get worse because of it either. However, if you use it correctly you can create miracles. Believe me I am not just being flip when I say the Happiness Code is the closest thing to having a Fairy God Mother that you will ever find.

When I first saw these techniques demonstrated many years ago, in their earlier form, I was very skeptical.

I know how all this may sound. About this time you might be thinking that the Happiness Code is just too weird for words, or, "isn't it just amazing how many nuts can get a book published?" Well I must admit that when I first saw these techniques demonstrated many years ago, in their earlier form, I was very skeptical. I attended a seminar for behavioral therapists who work with clients who have phobias. I watched the techniques, but I didn't believe it. I mean, come on, think of your fear and tap here and there on your body and the fear will be gone. What do you take me for, an idiot? Even though reputable practitioners were presenting the seminar, the speed that they were seemingly "curing" their test subjects was just too fast to be believed. I found myself doubting the credibility of the test subjects. It all seemed a little too "out there" for me to take it all seriously. When I got back to my office I threw the seminar notes and handouts in a desk drawer, all the while trying not to think of the large sum of money I had just wasted on the seminar.

Then about two weeks later, a woman came to me for help with a fear of driving. It seemed that for fifteen years, all of her driving life, she had been suffering with an intense fear of driving over bridges. She could not drive on a freeway. She spent fifteen years, her entire driving life, mapping out her route before she drove anywhere unfamiliar. If she came upon a bridge and could not turn

around and go back, someone would have to come and get her. And, there was no way she would ever think of getting on a freeway. This terrible fear had literally made her a prisoner of her own familiar neighborhood. By the time I interviewed her, she had already been through almost every kind of therapy you can think of, including hypnosis and systematic desensitization, the latter of which only made her fear worse.

Just as I was about to tell her that in her circumstance I really couldn't offer her any new hope, I thought of the silly tapping technique I had seen demonstrated at the seminar two weeks earlier. I retrieved my notes from my desk drawer and proceeded to read them to her. She followed the instructions step by step. I warned her that it might seem rather silly, but what did she have to lose? It only took about a minute to take her through the procedure, after which, with a funny look of puzzlement on her face, she exclaimed, "It's gone." I asked, "What's gone?" She told me, "The awful feeling in the middle of my chest when I think of driving on a freeway or over a bridge is gone." I asked her if it was gone enough to get in her car, with me as her passenger, and drive three blocks down the road and onto the freeway as a test.

I was shocked when she said, "Yes, let's try it!" Of course I didn't tell her that I was now fighting back fearful thoughts of being in a car with a driver who could panic at any minute. We got in her car and started off down the road. As we approached the freeway entrance, my anxiety levels were rising, but she seemed in comfortable control. She never wavered as she drove onto the freeway and merged into the light but steady freeway traffic. After we were about a mile down the road she said, "This is amazing!" She then began to cry, which worried me a bit. I asked her if she was ok, and with tears in her eyes she

sobbed, "I'm just so happy!"

Let me tell you it's moments like this that make life worth living. I must have had a smile on my face that beamed with the power of the sun. When I returned to my office I was walking on air. This time when I picked up those seminar notes from my desk, I felt like the sorcerer's apprentice who had just been given my own magic wand. Even now, after several years of study and successful use of this wonderful technology of the mind with thousands of people, I'm still blown away when a client gets that funny questioning look on their face and says, "Wow, that's amazing!" My usual response is, "Yes, you can learn something new everyday."

NOW IT IS UP TO YOU

How much better do you want your life to be? It's your choice. Once you have the information in this book, you have the key to set yourself free. It will unlock the door to the prison of fear, discomfort, and emotional misery that has been holding you back. Once you know how to recognize and release both the visible and invisible self-limiting conflicts that have been keeping you from your heart's desires, you can enter a pattern of success like you've never thought possible. Self-made barriers will dissolve like magic, and you will begin to see, think, and feel important positive changes in your life. In short, you will begin to walk the path of top performance and real personal power.

So once again I ask you, how much better do you want your life to be – physically, emotionally and spiritually? Things will never change if you don't. It's your choice!

LEVELS OF PARTICIPATION

There are four levels of participation with "THE HAPPINESS CODE".

1. **Total Rebuke** – You read the material, but because of the fear of change and of new ideas you decide to dismiss it: "I don't believe a word you said." *(You can't be bothered by truth.)*

2. **Light Curiosity and Interest** – You read the material and find it interesting, and you find an immediate benefit for others beside yourself. "These are pretty good ideas and methods. I know I don't need it, but I know some other people who really could use it." *(You're already perfect.)*

3. **Light Experimentation** – You lightly review the contents and try out a few techniques half-heartedly. At the first difficult moment, at the first sign of frustration you drop it. Or, you may even dissolve a single fear or phobia and then stop. "Well, I think I've gotten enough from this." *(If I can't change my whole life in just sixty seconds of thought and effort, why bother to continue?)*

4. **A Commitment to Change** – You read the material and decide to complete the entire process of self-improvement. You commit yourself to learn and utilize the techniques of dissolving your Invisible Self-Limiting Conflicts. It takes you a little longer, but you pay attention to the instructions I give you. You may only dissolve a few fears each day, but you keep going. Soon you begin noticing differences in your behavior. Others notice it too. You no longer just react to life. You seem to have greater freedom of choice. You

notice greater peace and contentment. Then you begin to get excited about the effectiveness of the Happiness Code. "Wow, this is amazing!" *(You are a proactive person who is always open to new ways of improving yourself.)*

I'll be happy as a clam with feet to guide and show you how easy it really is to get comfortable yet truly dramatic changes in your emotional comfort zone. So, as a great friend of mine once said, "Let's pull up our big girl panties and get started."

"If you continue to think of the things that are missing in your life, you will continue to attract the missing things."

Major Fears or Phobias

PERSONAL POWER IS BASED ON AN ABSENCE OF FEAR NOT OVERCOMING FEAR.

A simple phobia can be defined as a persistent intense fear of a thing or situation where no real immediate danger exists. This could be a fear of heights, spiders, snakes, flying, driving over bridges or through tunnels, dental procedures, needles, water, bees or other flying insects, and also the number one phobia in the United States, a fear of public speaking. Actually you can name just about any situation, action or object and someone somewhere has a fear attached to it. Now you might ask, "Where do all these fears and phobias come from?" Thanks. I was hoping you would ask me that.

The latest research shows that only about 30% of phobias are caused by traumas. So what about the other 70%? No one is really sure where the fears and phobias come from. We just have them.

No one is really sure where the fears and phobias come from. We just have them.

Most people who have a fear of heights have never fallen from a high place. Most with a fear of public speaking have never been booed off a stage. Most people who have a fear of snakes were never attacked or bitten by a snake. So, how did they acquire these fears?

There are a few theories about the origin of a non-trauma based phobia. One is that they are genetic survival

codes handed down from past generations. Another is that we learn to be afraid of something because someone else told us we should be. Once a fear becomes part of our belief system it operates in a false reality of our own creation. In essence, we ourselves create an imaginary trauma that our subconscious minds imprint upon our memory as real. Humans are the only species that can catch a fear from someone else without ever having experienced the problem themselves. Pretty scary, huh?

With most phobias the mind and body react as though they were in imminent danger. This kicks in the fight-or-flight response. The heart rate and breathing increases. Blood rushes away from the brain and into the larger muscles sometimes causing dizziness. Muscles become tense. All this happens even though the rational mind knows that no real danger or harm is imminent. It's an automatic defensive reaction that bypasses any critical decision-making function of the brain; the phobic individual has no control over it. These kinds of fear can be devastating to us in a number of ways. They cause us to judge ourselves as weak and/or inferior. Others may make fun of us, therefore we develop self-esteem problems. We even become afraid to let others know that we have these fears for fear of being ridiculed.

Sometimes we develop fear of the fear, which is a fear of being put in a situation where we might have to face what we are afraid of. Living in fear of the "what ifs" creates tremendous stress in our lives. In many cases fear of the fear brings on panic or anxiety attacks causing sufferers to get caught in a loop of fear. In this state of mind, rather than face our fears or maybe try to fix them, we alter our lifestyle to avoid situations that could trigger our fears. Think of how many people have passed up higher-paying positions in their companies or made demeaning career choices because of a fear. Perhaps it is a fear of new technology, which in

this day and age is a big fear in the baby boomer crowd. Maybe it is a fear of speaking to people we've never met, either in person or over the phone. In sales professions it's known as cold calling. We might pass up a management position because we know it would involve standing up in front of a group to speak. It is a shame that we have to live with this kind of internal tyranny. Fear eliminates choice and we become pathetic reactive shells of our true potential.

In my practice as a behavioral therapist, I had a gentleman come to me because he had a terrible fear of the dentist. In fact, it was his dentist that sent him to me. The man told me that he would feel major anxiety for days and weeks before his dental appointment. He would arrive on time for his appointment and sit in his car in front of the dentist's office until he was late, hoping when he went in it would be too late, and they would have to reschedule his appointment.

During our conversation he also mentioned that he had a dreadful fear of snakes, which was keeping him from enjoying his home on a lake. He would never walk from his house to the lake without a gun. Life on the lake for him was sitting on his screened-in porch or being armed and in fear. I told him I could help dissolve both his fear of dentistry and snakes during our one session. He looked pleased but skeptical.

His fear of dentistry was based on reoccurring traumas in the dentist chair from his childhood. As a child he had been subjected to many painful sessions by a dentist that had never invested in a high speed drill and also thought using Novocain to deaden pain was a waste of time. I asked him to think of himself sitting in a dental chair and give me a number from one to ten to describe the amount of fear he felt when thinking that thought, ten being feelings of panic and one being no fear at all. He told me it was a definite ten.

Understanding that his fear of the dentist was based on past traumas, the only way to get permanent relief from his current fear was to first dissolve the upset associated with his past childhood memories of being at the dentist's office. Using the technique I now call the Happiness Code, I started with his earliest memory of those painful events and came up through each memory that still bothered him. Those once painful memories became just memories with no upset attached.

Understand that this is a very thought specific technique so it was necessary to use the Code to dissolve the upset from each past memory, one at a time. He could now think of those once painful times with no discomfort at all. Having done that, I had him focus his imagination on being in the dentist chair now and in the future. Where that thought had previously gone to a ten on his discomfort scale, it was now just a four. He repeated the Code while thinking of being in the dentist chair now and in the future. His discomfort went down to a one. He was now completely free of any fear of dentistry. So that was one phobia down and one to go.

His fear of snakes was so severe that he wouldn't even let me bring out a toy rubber snake.

It was now time to dissolve his fear of snakes. His fear of snakes was so severe that he wouldn't even let me bring out a toy rubber snake that I keep as a test prop for just such occasions. He told me that if I brought it out he would leave my office. Just thinking of a snake made his fear zoom up to a ten. The good news was that since his snake phobia was not based on a past trauma, it was easier to dissolve than his dental phobia.

He had no idea why he had his snake fear. It had been with him as long as he could remember. So now, while thinking of a snake he went through the Code sequence, after

which his discomfort dropped down to a five. Upon repeating the Code sequence once again his fear completely dissolved. It took less than two minutes to eradicate his life-long fear of snakes. Before he left my office he was playing with the toy rubber snake, laughing about how silly it now seemed to have had such a fear. That happened some years ago. Today, he still reports no problems going to the dentist. Snakes are no longer an issue in his life. He retired his gun and has been enjoying the great outdoors and his home on the lake.

THE HAPPINESS CODE AND CHILDREN

The Happiness Code works well with all ages. Children have a variety of fears such as fear of the dark, fear of being alone in their room, fear of the monster under the bed or in the closet, fear of needles, fear of school, and fear of going to camp, fear of not being good enough, fear of not being accepted and a myriad of others. Just think of the things we were afraid of as a child, many of which we carried with us right into our adult lives, but now that can change. Think of the freedom from emotional pain we can now give our children and grand children by introducing them to the simple, powerful Happiness Code.

When children are shown how to use the magic buttons of the Happiness Code they are empowered. They can easily learn the Happiness Code sequence or you can do the touching on them yourself. I witnessed a three year-old boy who was screaming in fear of getting a haircut, calmed down immediately when his mother used the Happiness Code on him. Even though she used a shortened version of the code (no eye movement or humming) he was a smiling and willing participant in no time at all.

I remember a nine year-old girl who had a terrible fear of needles. Her father brought her to me and explained that

she had diabetes, which made it necessary for her to have insulin shots every day. She had such a fear of needles that, while fighting and screaming, she had to be held down by her father as her mother gave her the shot. He said he felt awful, like they were abusing her.

I showed her a chart which shows a series of six cartoon faces ranging from happy and smiling to sad and crying. I asked her to point to the picture that showed how she felt when thinking of a needle coming near her. She cringed and pointed to the saddest cartoon face.

I had her think of getting a shot while she followed along with me as I took her through the Happiness Code procedure. After completing one round of the Code I asked

her to point to the cartoon face that expressed how she felt when thinking of getting a shot. She pointed to the face that showed the beginning of a frown. I then took her through

the process once again and asked her how she felt now. The little girl pointed to the happiest face on the chart.

Her father had a look of confusion and disbelief. He asked me if the change had occurred because she was only in my office and not in the real situation or if maybe she was faking it just to please me. First of all, someone with a phobia can't fake not having it. I reminded him that a moment ago she was only in my office and had shown an over-the-top fear rating. So what had really changed, was it my office or her fear? He was flabbergasted. He said he had just witnessed a miracle. I get to see such miracles everyday. I love my job! The man called me later that day and reported his daughter received her shot with no emotional upset.

He said he had just witnessed a miracle. I get to see such miracles everyday.

WHY DO SOME PEOPLE HANG ON TO THEIR FEARS?

Would it surprise you to know that many people don't want to get rid of their fears? Why would any of us not want to dissolve a fear, especially if it could be done quickly and easily? The answer is because of fear. That's right many people have an underlying fear of losing their fear. What might be expected of us if we were no longer afraid? Who would we be?

During meetings or social occasions, I have had conversations with people who have expressed a fear of flying, public speaking, heights, spiders, etc. I tell them I could help dissolve that fear in just a few moments right then and there. (No charge) It's amazing how many people say, "Oh no that's okay." They don't even ask how I could back up such a bold statement. The thought of not having their fear scares them. Some people get caught up in what I

call loop thinking, which goes like this, "If I lose my fear of flying then I will be expected to fly and I am afraid to fly so I don't want to do anything." They can't grasp the idea that even without the fear they can still choose not to fly, but at least they would have a choice. The boundary of their fear has become familiar territory. Anything beyond that is a venture into the unknown, which on one level is scarier than the fear with which they have become so familiar.

There are individuals who want to keep their fear simply because it makes them special.

Then there are always those individuals who want to keep their fear simply because it makes them special. Other people will have to pay attention to them and cater to their problems. Many of these people are victim thinkers that confuse pity with love. They continue to go about mucking up their lives just to hear people say, "Oh you poor thing."

Some of us want to keep our fear because we think it motivates us. If I'm afraid to be poor then I'll strive to be rich. Striving to be rich out of fear will likely cause us to bend our own moral standards. We justify negative and hurtful actions. The presence of fear projects negative energy, and the energy we project will always be reflected back into our lives. Some people rationalize that fear is a necessary component of a normal life. That's an ugly scenario. There is a difference between common sense or respect for actual danger and the fear I'm describing. I don't need a fear of heights to keep me from jumping off a bridge. That would be like saying that without fear we would become suddenly stupid and irresponsible.

Does fear really keep us safe? If it protects us from anything it is protecting us from the truth. If I lose the weight I might have to deal with the real reason people don't

like me. As long as I have this fear of not being enough (low self esteem), I have a reason for failure. As long as I fear your religion, I don't have to take a serious look at my own beliefs. We need to ask ourselves this question, "Am I brave enough to live without fear?" I say we can handle the truth and the Happiness Code can help us do it comfortably.

DISSOLVING A MAJOR FEAR OR PHOBIA – THE METHOD

Important: If your fear is based on a past traumatic event you must first use the code to dissolve the upset you feel when remembering that original event. In other words if you have a fear of heights because you fell off a roof or out of a tree, to get lasting relief from your present fear you must think back to the time you fell and use the Code to make that memory comfortable. Then you can focus on your present fear of heights and once again use the Code to dissolve it. By first dissolving the original upset you will have neutralized any driving force behind your fear that might cause it to reappear later.

Think of something you have a major fear of like Spiders, Snakes, Flying, Public Speaking, etc. and measure the strength of the fear you feel on a ten point scale where 10 is the highest it can be and 1 is no fear at all.

While you think about what bothers you, use just *two fingers* and while breathing normally, lightly touch each place on your body shown on the diagram on the following page. Touch each place for about *4 or 5 seconds*, and touch the points in the *exact order* shown by the numbers, 1 to 15.

It doesn't matter which side of the face or body you touch. The points are duplicated on both sides. You can even switch hands during the sequence. Use either hand to touch.

Setup phrase of acceptance: Some practitioners think that it is important to always use a setup phrase of acceptance, some don't. I think it's a good idea to use it because it seems to help focus the thought pattern in the correct polarity to allow a positive change.

The setup phrase of acceptance is done by touching the #1 spot shown on the chart. I call it the reset point. It is located on the outer edge of the hand and is the point one would use to deliver a karate chop. While touching this point you say your setup phrase of acceptance such as, ***"Even though I have this fear of spiders, I totally love and accept myself."*** You don't have to believe your statement, just say it anyway. You then focus on your fear while touching the remaining points in the order shown.

(Note: Touching point #9 may be omitted most of the time. If you don't get relief, put #9 back into the sequence and try again. Point #9 is located one inch below the nipple on a man. For women it is where the under skin of the breast meets the chest.)

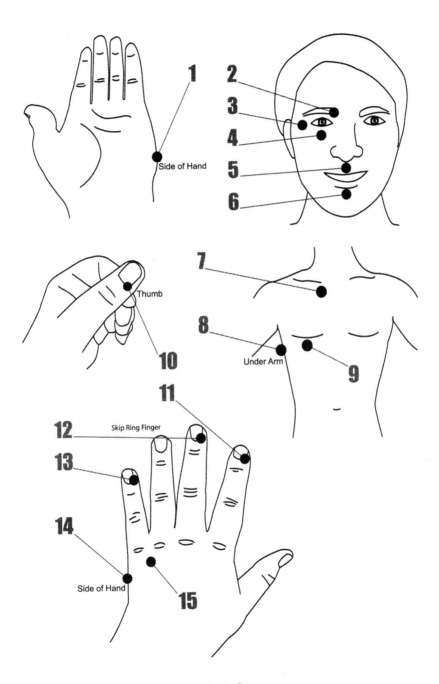

The Happiness Code Sequence

Now continue touching the #15 spot while you:

a. Close your eyes and open them again;

b. Move your eyes down and to the right and then down and to the left;

c. (Still touching #15) Whirl your eyes in a complete circle;

d. Whirl your eyes in the other direction;

e. Stop eye movement, but keep touching #15 and hum a 5-second tune;

f. Count to five out loud (1-2-3-4-5);

g. Hum a tune again.

Again access the thought that was bothering you when you first started the sequence. The fear should be gone or lower. Feelings about the past issue should be more comfortable.

If the feelings are better but not completely comfortable, refocus on the problem thought and repeat the process.

Do not try to think positive or try to push the bad feelings away during the process. The upset feelings will dissolve on their own. It is not a distraction technique, if it was, the problem would pop back the minute you thought about it again. As long as you have dissolved the core issue driving the bad feelings, it won't.

Also, understand that some fears have more than one piece or aspect to them. The Happiness Code is a very thought specific technique, so if a perceived threat has more than one part to it, each part needs to be neutralized. For instance, when working with someone who has a fear of spiders, I always ask them after they completed the code and feel comfortable with the thought of spiders, if the spider

they thought about was standing still or moving. If the spider they imagined was still, sometimes the thought of it moving will cause discomfort. They would now need to think of a moving spider and repeat the code sequence thus totally dissolving all aspects of the fear.

"Change your thoughts and you change your life"
- *Norman Vincent Peale*

Panic Attacks

You haven't lived until you have experienced a full blown panic or anxiety attack. I should probably rephrase that to say, you haven't thought you were dying until you have experienced a panic or what is sometimes referred to as an anxiety attack. The symptoms that accompany such attacks may vary in intensity and include, shortness of breath, tightness in the chest, elevated heart rate, disorientation or dizziness, cold clammy skin, sweating, even fainting. Basically, in a panic attack the mind body system has turned on all its alarms at once. Such occurrences can be brought on due to sudden physical changes in the body, maybe linked to blood pressure or blood sugar levels. Extreme emotional stress can also be a trigger. Often there seems to be no recognizable cause. It just happens. The intensity can be so strong, that it's easy to see why these anxiety or panic attacks are often confused with heart attacks.

I had the honor of experiencing a panic attack myself. I say had the honor, because I can now identify with my clients that report such events. A few years back while leaving a retreat I had been attending in Kentucky, an attack hit me like a ton of bricks. I had just gotten into my vehicle and was preparing to drive home to Michigan. It was the most overwhelming feeling I've ever had. If I hadn't known the symptoms of a panic attack so well, from working with so many clients who experienced

them, I would have thought I was dying. Had I not known the Happiness Code I would have been compelled to go to a hospital for treatment. There would have been no way for me to drive home on my own. As it turned out, fortunately for me, I knew the Code and used it. After the first time through I noticed a slight improvement so I went through the sequence a second time. After the second run through I felt much better but I used the Code one more time for good measure. After the third time I felt great. Even though I had no idea what brought it on, I now had a real sense of peace that it would not return. It hasn't to this day, and if it ever does, no big deal.

Once a person has experienced a panic attack it is common for them to then develop what is known as "fear of the fear."

Once a person has experienced a panic attack it is common for them to then develop what is known as fear of the fear. Since the original attack came on without warning and was so intense and scary, they now have a fear of it happening again. Thus they now have a fear of the fear coming back. This fear of the fear can now initiate another panic attack and just compound the problem.

I had a man come to me for help with what he called a fear of driving a car. He was 67 years old and for the last two years just the thought of getting in his car and driving anywhere brought on unbearable anxiety. After talking with him about his problem it was obvious that the problem was not a fear of driving, rather it was fear of the fear. You see two years earlier he had been driving down the road alone in his car and had experienced a panic attack. He had to stop his car in the middle of a busy road. He opened his door and fell to the pavement.

His senses were overwhelmed with fear, his body and car blocking traffic. Bystanders called 911 and he was taken to a hospital where after testing it was determined that he had not suffered a heart attack but had suffered a panic attack. The trauma of the attack along with the embarrassment he suffered in public now triggered a fear of it happening again. So he really didn't have a fear of driving. What he had was a fear of the fear.

I had him think back to the original incident and give me a number on a scale from one to ten describing how much the memory of it bothered him. He said it was definitely a ten. He also said that his fear of it happening again was a ten. While touching the #1 spot on his hand, I had him use this set up phrase, "Even though I was so scared during the panic attack in my car that I couldn't even move, I totally love and accept myself." Now while he continued to think of how scary the incident was, I took him through the Happiness Code. He said that his discomfort had dropped to a six. So now while touching the #1 spot on his hand I had him say, "Even though I feel embarrassed about my attack and all those people were looking at me, I totally love and accept myself." We then went through the Code again. His discomfort had dropped to a two. One more round of the Code completely eliminated any discomfort he had when remembering the incident. He also reported that his fear of it happening again was now down to a five. He now used the setup phrase, "Even though I have some fear of my panic attack happening again, I totally accept myself." And while focused on the thought of it happening again he repeated the Code sequence after which he said that any remaining discomfort had totally disappeared. He has been driving for over a year now with no reoccurrence of the problem. He also feels

reassured that if it was to happen again he could casually use the Code to fix the problem quickly.

DISSOLVING A PANIC ATTACK – THE METHOD

Think of the panic feeling you are having. Rate the discomfort you feel while thinking of it on a scale of one to ten, ten being the worst you can imagine and one being no discomfort at all.

While you continue to think about awful you feel, use just *two fingers* and lightly touch each place on your body shown on the diagram on the following page. Touch each place for about *4 or 5 seconds*. Breathe normally while touching the points in the *exact order* shown by the numbers.

It doesn't matter which side of the face or body you touch. The points are duplicated on both sides. You can even switch hands during the sequence. Use either hand to touch each point 1 – 15.

Setup phrase of acceptance: Some practitioners think that it is important to always use a setup phrase of acceptance, some don't. I think it's a good idea to use it because it seems to help focus the thought pattern in the correct polarity to allow a positive change.

The setup phrase of acceptance is done by touching the #1 spot shown on the chart. I call it the reset point. It is located on the outer edge of the hand and is the point one would use to deliver a karate chop. While touching this point you say your setup phrase of acceptance such as, **"Even though I have this overwhelming feeling of panic, I totally love and accept myself."** You don't have to believe your statement, just say it anyway. You then focus on your fear while touching the remaining points in the order shown.

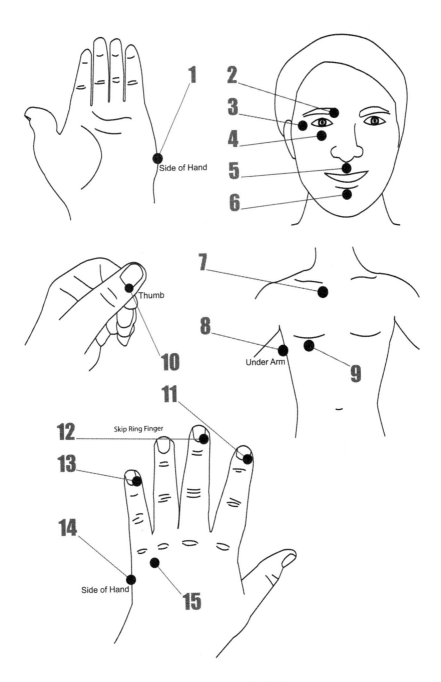

The Happiness Code Sequence

(Note: Touching point #9 may be omitted most of the time. If you don't get relief, put #9 back into the sequence and try again. Point #9 is located one inch below the nipple on a man. For women it is where the under skin of the breast meets the chest.)

Now continue touching the #15 spot while you:

 a. Close your eyes and open them again;

 b. Move your eyes down and to the right and then down and to the left;

 c. (Still touching #15) Whirl your eyes in a complete circle;

 d. Whirl your eyes in the other direction;

 e. Stop eye movement, but keep touching #15 and hum a 5-second tune;

 f. Count to five out loud (1-2-3-4-5);

 g. Hum a tune again.

Again access the thought that was bothering you when you first started the sequence. The fear should be gone or lower. Feelings about the past issue should be more comfortable.

If the feelings are better but not completely comfortable, refocus on the problem thought and repeat the process.

Do not try to think positive or try to push the bad feelings away during the process. The upset feelings will dissolve on their own. It is not a distraction technique, if it was, the problem would pop back the minute you thought about it again. As long as you have dissolved the core issue driving the bad feelings, it won't.

Once the panic has been neutralized, if there is any fear of it happening again, use the Code to dissolve that fear of the fear.

"Living on purpose is living a life of purpose."

Guilt, Shame, or Embarrassment

We have all done things we felt guilty, ashamed or embarrassed about. However it is important to understand guilt, shame, and embarrassment are wasted emotions. They don't fix anything or help anyone. Feeling guilty, ashamed or embarrassed does not make us a better person. Such feelings are nothing more than a form of self-punishment. When we dwell on these negative emotions we disturb the vital life functions of the mind and body, inviting illness and depression. Harboring guilt or shame serves no purpose. It doesn't right any wrongs. When we use guilt or shame as self-punishment we break a vital law of nature. Everyone makes mistakes, and the positive response is to learn from them and move on! We have a right to be wrong, but we have no right to punish our God given, healthy minds and bodies.

> *Guilt, shame and embarrassment are wasted emotions!*

Sure, we should atone for general wrongs but then we must get on with living. If we really cause some harm, we should do everything to restore or resolve those errors. We should do all we can to make things better. However, we are not doing anyone a favor by feeling guilty, ashamed or embarrassed about anything.

We should examine the standards by which we judge ourselves. Are they the true standards we now accept, or are they the ones drummed into us by others with their own

agendas? When others try to make us feel guilty, they are only trying to manipulate us and get their own way.

People often act without the full knowledge of the consequences.. Even when parents try their best, they can never know enough to always deal perfectly with the problems of their children. Realize this truth – it is impossible to obtain universal approval for our acts and decisions. No matter how hard we try, we will never please everyone. The other people in our lives, even the really important people, are after all, individuals. Each of us is responsible for our own feelings. So if we concentrate on living well and decently in the presence of others, according to standards we think are correct for us, we will then be able to handle with less discomfort other people's criticisms or disappointments.

So, let's ask ourselves what we have done in the past where we feel guilty, ashamed or embarrassed. It is now time to throw those heavy weights off our shoulders.

DISSOLVING GUILT, SHAME OR EMBARRASSMENT – THE METHOD

Think of what you feel guilty, ashamed or embarrassed about. Rate the discomfort you feel while thinking of it on a scale of one to ten, ten being the worst you can imagine and one being no discomfort at all.

While you continue to think about awful you feel, use just *two fingers* and lightly touch each place on your body shown on the diagram on page 66. Touch each place for about *4 or 5 seconds*. Breathe normally while touching the points in the *exact order* shown by the numbers.

It doesn't matter which side of the face or body you touch. The points are duplicated on both sides. You can even switch hands during the sequence. Use either hand to touch each point 1 – 15.

Setup phrase of acceptance: Some practitioners think that it is important to always use a setup phrase of acceptance, some don't. I think it's a good idea to use it because it seems to help focus the thought pattern in the correct polarity to allow a positive change.

The setup phrase of acceptance is done by touching the #1 spot shown on the chart. I call it the reset point. It is located on the outer edge of the hand and is the point one would use to deliver a karate chop. While touching this point you say your setup phrase of acceptance such as, **"Even though I have these uncomfortable feelings about** (name what you're uncomfortable about), **I totally love and accept myself."** You don't have to believe your statement, just say it anyway. You then focus on your fear while touching the remaining points in the order shown.

(Note: Touching point #9 may be omitted most of the time. If you don't get relief, put #9 back into the sequence and try again. Point #9 is located one inch below the nipple on a man. For women it is where the under skin of the breast meets the chest.)

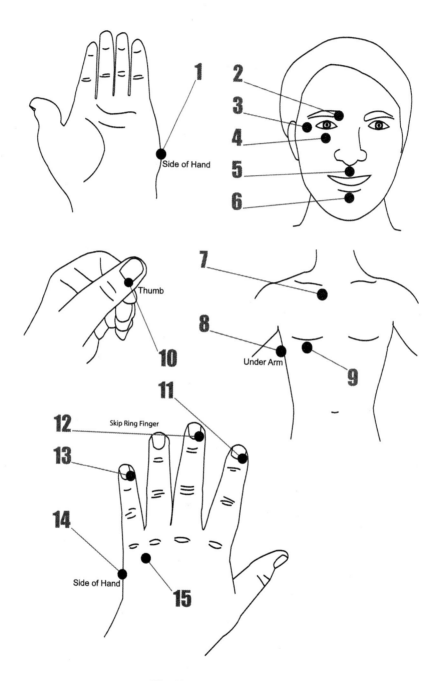

The Happiness Code Sequence

Now continue touching the #15 spot while you:

a. Close your eyes and open them again;

b. Move your eyes down and to the right and then down and to the left;

c. (Still touching #15) Whirl your eyes in a complete circle;

d. Whirl your eyes in the other direction;

e. Stop eye movement, but keep touching #15 and hum a 5-second tune;

f. Count to five out loud (1-2-3-4-5);

g. Hum a tune again.

Again access the thought that was bothering you when you first started the sequence. The fear should be gone or lower. Feelings about the past issue should be more comfortable.

If the feelings are better but not completely comfortable, refocus on the problem thought and repeat the process.

Do not try to think positive or try to push the bad feelings away during the process. The upset feelings will dissolve on their own. It is not a distraction technique. If it was, the problem would pop back the minute you thought about it again. As long as you have dissolved the core issue driving the bad feelings, it won't.

Once the bad feeling has been neutralized, if there is any fear of it happening again, use the Code to dissolve that fear of the fear.

Also, understand that some issues have more than one piece or aspect to them. The Happiness Code is a very thought-specific technique, so if a perceived threat has more than one part to it, each part needs to be neutralized separately.

"Live in a state of cooperation, not competition."

Anger

I had a client who came to me for stress relief. She worked in the advertising business where deadlines and constant clashing of creative egos was the norm. She had arrived a bit late for her appointment, which she blamed on the traffic lights and stupid idiot drivers who where going so slow in front of her. (How's that for victim thinking?) She said that stress was causing her to break out in hives and she was thinking of quitting her job.

I asked her why she was so angry, and as tears welled up in her eyes she sobbed, "I just can't take this &%$@# anymore!" She went on to explain that a department head in charge of ad layout had changed the ad copy she had spent a week writing, and he hadn't even consulted her before doing so. I then asked if she had spoken with the department head about it and she said, "Screw it; I'm just going to quit." It was obvious that this lady was the type who had learned to avoid confrontation even if it would mean the loss of her job. She stuffed her anger and it was now surfacing in the form of anxiety, and with it, the passive aggressive action of quitting her job, along with the physical manifestation of hives.

I asked her to rate her anger about the ad copy change on a scale of one to ten. She put it at a twenty. She said, "It was the last straw" and she just wanted to punch him. I led her through the Happiness Code, beginning, with the setup phrase, "Even though I want to punch him, I choose to

accept myself." Her anger came down to an eight. She then went through the Code again, using the setup phrase, "Even though I feel hurt about not being consulted, I choose to accept myself." Her anger was now at a four. Now after changing the setup to, "Even though I feel unappreciated at work, I choose to accept myself." And after repeating the Code one last time, her anger was at a one.

The look on her face had softened, and after she contemplated her feelings she smiled and said, "Maybe I won't quit after all."

We then talked about her childhood and her fear of her father's bad temper. She was always afraid to speak up for fear of being yelled at and ridiculed. Never being able to express her opinion made her feel powerless. We used the Happiness Code to dissolve the anger and resentment from those childhood days. She said it was as if a huge weight had been lifted from her chest. No longer feeling the old anger at her father, she now felt sorry for him, and the fact that he had to live his life so full of his own fear and anger.

The good news is that she didn't quit her job. She was able to speak with the department head that had changed her copy, and she did it without getting angry. He apologized to her, and explained it was a last minute change by the client who wanted the whole ad to go in a different direction. He applauded her work and dedication, and said she was a very important part of their team. She also told me that her hives had completely disappeared.

Anger weakens us both mentally and physically. If you don't believe that then you should try the muscle testing I described earlier. (Once again, you should avoid doing this demonstration if you have a bad back or other arm or shoulder injury.) While thinking something

you think is wonderful, hold one of your arms straight out sideways and keep it stiff while someone pushes down on your arm firmly at the wrist with their hand. It should be fairly easy to resist the pressure. Now while thinking something you are angry about, have the person push down again. Your arm will weaken and may even collapse altogether. It is the best demonstration of how your thought patterns affect your body that I've ever seen. When we think comfortable thoughts our energy system supports it. When we are thinking negative thoughts, those thoughts are toxic to our energy system and weaken it.

When we are thinking negative thoughts, those thoughts are toxic to our energy system and weaken it.

Of course we can justify our anger and rant on about how we have been wronged and that we have a right to be angry, but as we see from the above test, every time we get angry we become weakened by it. So, who are we really hurting, them or us? We get caught up in victim thinking and play the blame game by saying things like, "He makes me so mad." Or, "That makes me so mad." Just think of the power we dump when we say things like that. We become a victim, and all that goes with it. Not being a victim is all about choices. Yes we can choose to be angry if we want to. We can also choose to jump off a bridge if we want to, but who are we really hurting when we make either of those choices? The Happiness Code can be used to dissolve current anger or anger associated with past issues or events. The choice is ours.

DISSOLVING ANGER – THE METHOD

Think of something you get angry about. Rate the anger you feel while thinking of it on a scale of one to ten, ten being the worst anger you can imagine and one being no anger at all.

While you continue to think about awful you feel, use just *two fingers* and lightly touch each place on your body shown on the diagram on the following page. Touch each place for about *4 or 5 seconds*. Breathe normally while touching the points in the *exact order* shown by the numbers.

It doesn't matter which side of the face or body you touch. The points are duplicated on both sides. You can even switch hands during the sequence. Use either hand to touch each point 1 – 15.

Setup phrase of acceptance: Some practitioners think that it is important to always use a setup phrase of acceptance, some don't. I think it's a good idea to use it because it seems to help focus the thought pattern in the correct polarity to allow a positive change.

The setup phrase of acceptance is done by touching the #1 spot shown on the chart. I call it the reset point. It is located on the outer edge of the hand and is the point one would use to deliver a karate chop. While touching this point you say your setup phrase of acceptance such as, **"Even though I have this anger about** (state what you're angry about), **I totally love and accept myself."** You don't have to believe your statement, just say it anyway. You then focus on your fear while touching the remaining points in the order shown.

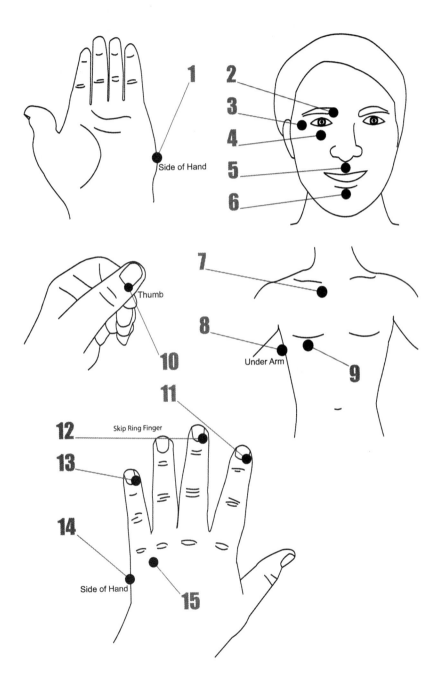

The Happiness Code Sequence

(Note: Touching point #9 may be omitted most of the time. If you don't get relief, put #9 back into the sequence and try again. Point #9 is located one inch below the nipple on a man. For women it is where the under skin of the breast meets the chest.)

Now continue touching the #15 spot while you:

 a. Close your eyes and open them again;

 b. Move your eyes down and to the right and then down and to the left;

 c. (Still touching #15) Whirl your eyes in a complete circle;

 d. Whirl your eyes in the other direction;

 e. Stop eye movement, but keep touching #15 and hum a 5-second tune;

 f. Count to five out loud (1-2-3-4-5);

 g. Hum a tune again.

Again access the thought that was bothering you when you first started the sequence. The anger should be gone or lower. Feelings about the past issue should be more comfortable.

If the feelings are better but not completely comfortable, refocus on the problem thought and repeat the process.

Do not try to think positive or try to push the bad feelings away during the process. The upset feelings will dissolve on their own. It is not a distraction technique. If it was, the problem would pop back the minute you thought about it again. As long as you have dissolved the core issue driving the bad feelings, it won't.

Once the anger has been neutralized, if there is any fear of it happening again, use the Code to dissolve that fear of the fear.

Also, understand that some issues have more than one piece or aspect to them. The Happiness Code is a very thought-specific technique, so if a perceived threat has more than one part to it, each part needs to be neutralized separately.

"Forgiveness feeds your spiritual nature."

The Pain of Grief or Lost Love

Many of us have suffered the pain of losing someone we love either through a death or a breakup of a relationship. Over the years several people have called my office to ask if there is some way I can help them forget something or someone. I tell them that although I can't help them forget anything, I can help them not be bothered by what they remember. The pain of a lost loved one can be excruciating. It can last for years or decades. Using the Happiness Code is the best way I know to dissolve such pain quickly. I used it for myself when my father died. I also showed my mother how to use the technique. She later thanked me and said she didn't know how she would have gotten through those harrowed days had it not been for the Code.

Here I would like to note that some people resist the thought of using the Code to feel better about the loss of a loved one. They seem to think that not feeling the terrible pain of loss somehow devalues the person who died. I disagree. If you died would you want people not to think about you because it hurt too much when they did? Of course not, you would want people to think of you and smile when the memory of you is in their mind. Besides, using the Happiness Code for grief doesn't make you happy they're gone. It just takes away that overwhelming, crushing pain of lost love or loved one.

> *If you died would you want people NOT to think about you because it hurt too much when they did?*

It is also important to realize that the Code is a very thought specific technique and in the case of lost love, whether through death or breakup, it should not only be used to dissolve pain from the global idea of loss, but also to dissolve the pain of any specific memory that seems to bring back those terrible feelings of loss, such as a certain song or place that reminds you of them. Wouldn't it be better to remember them with a smile than a sob? If there is anger about a loss or breakup, maybe you feel used or betrayed, you can use the Happiness Code to dissolve it rather than have it eat you up and ruin future relationships. In other words, do us all a favor and dump that old baggage. We can always justify our anger if we choose to, but anger and resentment for any reason, justified or not, are low energies and always weaken us.

If you have trouble getting lasting relief from the pain of loss, it is usually because it is rooted or attached to another issue.

If you have trouble getting lasting relief from the pain of loss, it is usually because it is rooted or attached to another issue. Until the root cause is discovered and dissolved it will continue to resurface. Just like mom said, "If you don't pull the weed out by the roots, it will grow back."

For instance, not too long ago I met a fascinating woman while traveling down the Amazon River. (How many people can say that?) The trip was a glorious experience. Words can't define how truly wonderful it was. Then add the element of connecting romantically with a beautiful being of light and love! It was magical. I was truly smitten by it all. But, once we were back home things began to look different. We both lived in different parts of the country. She didn't want to move to my state and I could tell she was uncomfortable with any thoughts I had of moving to hers. The more I pushed for maintaining even a long distance

romantic relationship the more she pulled away. I felt devastated. How could I feel so strongly about someone without them also feeling that way about me? I couldn't stop thinking about her. Intellectually, I knew that I didn't really know her well enough to be so totally caught up in her. I also realized that it was only the fantasy expectations that I had created myself that were offending me. It wasn't the real her that I was in love with. What I loved was an idea I had that looked like her. So if I new all of that, why did it still hurt so much?

Of course, I used the Happiness Code to take away the pain, and it did help get me through the day, but I just couldn't seem to shake it completely. I began to realize that for this loss to hang on as it was, it must be tied to some other issue. I thought that maybe, for some unknown reason, a part of me wanted to keep the pain. So I tried using setup phrases like, "Even though I think I deserve this pain of loss, I completely accept myself." Then I tried, "Even though I don't want to get over this pain, I completely accept myself." None of it seemed to be working.

Suddenly, a memory popped into my mind. It was of a time when I was thirteen, almost fourteen years old. My family and I were visiting various relatives who lived in another State. Because of the long travel distance we only saw these people maybe once every three or four years. On our way home we stopped at my aunt and uncle's house to visit for the day, spend the night and then travel on. Which I'm sure so far seems pretty benign, but I made a discovery. My absolutely drop dead gorgeous very sexual female cousin, who is also about fourteenish, now enters the picture. Now, I wasn't really thinking of her as close family – partly because I hardly ever saw these people, and partly because of raging teenage hormones. Yes, I know I'm justifying, but to me she was this beautiful girl who seemed hot for me. We went for a bike ride to a park near her

house. We sat next to each other at the base of a big tree. I put my arm around her. She snuggled in next to me. And then she deliberately moved my hand from her shoulder to her breast!

My feelings were overwhelming! It was as if an emotional atom bomb had gone off inside me. At that moment every part of my mind and body screamed that I was in love!! Later that evening we made a pact to sneak together after our parents went to bed.

Well, our parents stayed up half the night playing cards and the next thing I new it was morning and we were leaving. I really can't explain the amount of emotional pain that consumed me. I couldn't even talk – not that I could have told anyone anyway. On the fifteen hour ride home I sat in silence and in the depths of personal depression.

My depression lasted for months and months. I don't think my parents even noticed.

My depression lasted for months and months. I don't think my parents even noticed. They thought I was just the strange moody kid I always was. That incident and the pain of loss imprinted so strongly into my psyche that my beautiful cousin became a fantasy that I carried right into adulthood. It became a massive self-limiting conflict – a time bomb planted to go off whenever the tripwire was struck.

And now, as this memory flashed in my mind, I realized it was the root cause of my current lost-relationship pain. You see, I suddenly become aware that this current lady's voice sounded exactly like I remembered my cousin's voice sounding. On top of that even some of her looks and mannerisms seemed similar.

So, while holding the memory of that first major lost love – which had occurred some forty-five years ago – in my

mind, I went through the Happiness Code sequence. The result was a quantum shift in my comfort zone. Not only was any pain from that memory instantly gone, but any lingering pain I still had over losing what in my mind "might have been" had things worked out differently with my Amazon River relationship, was also gone. There was no anger and no resentment; I was just feeling thankful that I now had a great friend and we had the good fortune of each others' company to share an experience that few people get to have in life. I was free from my drama of what could have been and completely comfortable with what really was.

DISSOLVING THE PAIN OF GRIEF OR LOST LOVE – THE METHOD

Think of something or someone you feel the pain of loss about. Rate the strength of the emotional pain you feel while thinking of it on a scale of one to ten, ten being the worst pain you can imagine and one being no pain of loss at all.

While you continue to think about awful you feel, use just *two fingers* and lightly touch each place on your body shown on the diagram on the following page. Touch each place for about *4 or 5 seconds*. Breathe normally while touching the points in the *exact order* shown by the numbers.

It doesn't matter which side of the face or body you touch. The points are duplicated on both sides. You can even switch hands during the sequence. Use either hand to touch each point 1 – 15.

Setup phrase of acceptance: Some practitioners think that it is important to always use a setup phrase of acceptance, some don't. I think it's a good idea to use it because it seems to help focus the thought pattern in the correct polarity to allow a positive change.

The setup phrase of acceptance is done by touching the #1 spot shown on the chart. I call it the reset point. It is located on the outer edge of the hand and is the point one would use to deliver a karate chop. While touching this point you say your setup phrase of acceptance such as, **"Even though I have this pain of losing** (state what or who you've lost), **I totally love and accept myself."** You don't have to believe your statement, just say it anyway. You then focus on your fear while touching the remaining points in the order shown.

(Note: Touching point #9 may be omitted most of the time. If you don't get relief, put #9 back into the sequence and try again. Point #9 is located one inch below the nipple on a man. For women it is where the under skin of the breast meets the chest.)

Now continue touching the #15 spot while you:

 a. Close your eyes and open them again;

 b. Move your eyes down and to the right and then down and to the left;

 c. (Still touching #15) Whirl your eyes in a complete circle;

 d. Whirl your eyes in the other direction;

 e. Stop eye movement, but keep touching #15 and hum a 5-second tune;

 f. Count to five out loud (1-2-3-4-5);

 g. Hum a tune again.

Again access the thought of grief or lost love that was bothering you when you first started the sequence. The pain should be gone or lower. Feelings about the past issue should be more comfortable.

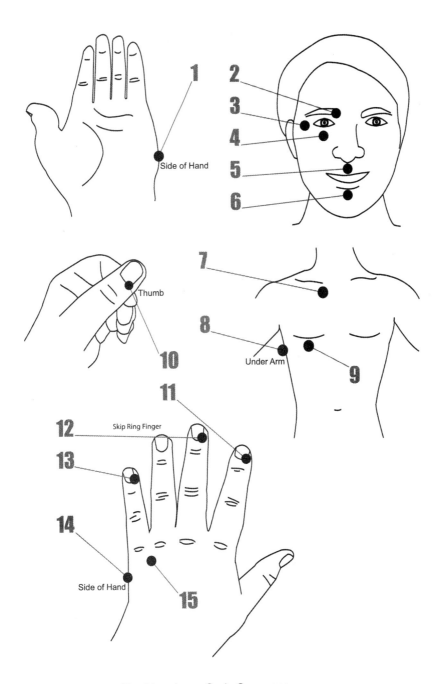

The Happiness Code Sequence

If the feelings are better but not completely comfortable, refocus on the problem thought and repeat the process.

Do not try to think positive or try to push the bad feelings away during the process. The upset feelings will dissolve on their own. It is not a distraction technique. If it was, the problem would pop back the minute you thought about it again. As long as you have dissolved the core issue driving the bad feelings, it won't.

Once the pain has been neutralized, if there is any fear of it happening again, use the Code to dissolve that fear of the fear.

Also, understand that some issues have more than one piece or aspect to them. The Happiness Code is a very thought-specific technique, so if a perceived threat has more than one part to it, each part needs to be neutralized separately.

Anxiety or Depression

Chronic anxiety and depression are becoming rampant in the United States. Some people are beginning to think that it is normal for people to be on some sort of mood altering drug. Well listen up folks, it's NOT normal!!! We have become so fearful of life that many of us are in high anxiety (fight response) or in depression (flight response) on a daily basis. Millions of people are being prescribed various drugs in an attempt to dampen the brains' response to these perceived threats. Wouldn't it be better for our brain to no longer perceive an issue as a threat in the first place? Of course.

As we've discussed, our brains and our run with electricity. That's correct. Brain activity is a series of electrically coded impulses carried by specialized cells called neurons, of which there are about 100 billion in the brain. These neurons and their attached dendrites and axons connect across synapses through chemicals known as neurotransmitters. These chemicals change in our brain according to how information is interpreted. Some of these chemicals support the transmission of thoughts interpreted as threatening, while different chemicals support the transmission of non threatening thought patterns.

When we suffer from anxiety or depression it is because the Amygdala, think of it as the brain's central alarm system, is constantly sounding an alarm. How would any of us feel if we were stuck in a building with fire or burglar alarms

constantly screeching? We might be constantly running back and forth, always trying to find a way out (anxiety), or resign ourselves to the fact that there is no way out so we just sit in a corner with a blanket over our head trying to deaden the sound (depression).

In most cases today's standard anxiety or depression remedy is to give us one of the many drugs developed to change our brain chemistry. The number of people "on" one or another of these drugs is truly alarming. Using these drugs is like walking a tight rope. The side effects can be nasty.

When we perceive something as a threat our brain chemistry changes to facilitate the fight or flight response to protect us.

The problem is that many doctors have been told that our brain chemistry causes our thought patterns to be happy or sad, when in most cases it is the other way around. Our thought patterns cause the changes in brain chemistry. If we are feeling anxious or depressed it is usually due to feeling threatened or overwhelmed by one or more events or situations in our lives. But it's not the situation itself that causes our pain. It is our thought pattern(s) about the situation. In this context, perception is one hundred percent of the law. When we perceive something as a threat our brain chemistry changes to facilitate the fight or flight response to protect us. Our brain is constantly being sent an alarm signal. Taking a drug to fix it is like sticking our fingers in our ears so we no longer hear the alarm. Using the Happiness Code is like turning off the alarm.

Of course there are some exceptions to that scenario. Which came first, the chemical change or the thought pattern argument? Post partum depression is certainly one of those exceptions. The process of pregnancy and delivery can really mess with our mind-body chemistry. In any case, if it were me, I would try the Code before using a drug.

Warning: DO NOT JUST STOP USING ANY MEDICATION YOU ARE CURRENTLY TAKING WITHOUT CONSULTING YOUR PHYSICIAN. Such action could cause a sudden jolt to your mind body system that would be difficult to balance or recover from.

DISSOLVING ANXIETY OR DEPRESSION – THE METHOD

Think of something or someone you feel anxious or depressed about or if you are not sure what you are anxious or depressed about just think about how anxious or depressed you feel. Rate the strength of the emotional discomfort you feel while thinking of it on a scale of one to ten, ten being the worst discomfort you can imagine and one being no discomfort at all.

While you continue to think about awful you feel, use just *two fingers* and lightly touch each place on your body shown on the diagram on the following page. Touch each place for about *4 or 5 seconds*. Breathe normally while touching the points in the *exact order* shown by the numbers.

It doesn't matter which side of the face or body you touch. The points are duplicated on both sides. You can even switch hands during the sequence. Use either hand to touch each point 1 – 15.

Setup phrase of acceptance: Some practitioners think that it is important to always use a setup phrase of acceptance, some don't. I think it's a good idea to use it because it seems to help focus the thought pattern in the correct polarity to allow a positive change.

The setup phrase of acceptance is done by touching the #1 spot shown on the chart. I call it the reset point. It is

located on the outer edge of the hand and is the point one would use to deliver a karate chop. While touching this point you say your setup phrase of acceptance such as, **"Even though I have this anxiety about** (state what or who you're nervous or anxious about), **I choose to love and accept myself."** You don't have to believe your statement, just say it anyway. You then focus on your fear while touching the remaining points in the order shown.

(Note: Touching point #9 may be omitted most of the time. If you don't get relief, put #9 back into the sequence and try again. Point #9 is located one inch below the nipple on a man. For women it is where the under skin of the breast meets the chest.)

Now continue touching the #15 spot while you:

 a. Close your eyes and open them again;

 b. Move your eyes down and to the right and then down and to the left;

 c. (Still touching #15) Whirl your eyes in a complete circle;

 d. Whirl your eyes in the other direction;

 e. Stop eye movement, but keep touching #15 and hum a 5-second tune;

 f. Count to five out loud (1-2-3-4-5);

 g. Hum a tune again.

Again access the thought that was bothering you when you first started the sequence. The emotional discomfort should be gone or lower. Feelings about the past issue should be more comfortable.

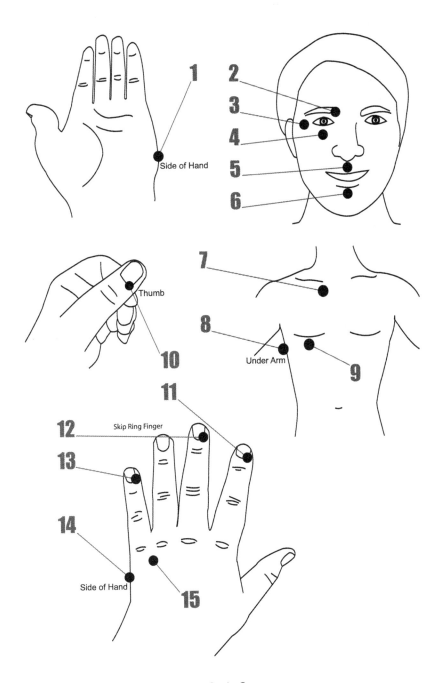

The Happiness Code Sequence

If the feelings are better but not completely comfortable, refocus on the problem thought and repeat the process.

Do not try to think positive or try to push the bad feelings away during the process. The upset feelings will dissolve on their own. It is not a distraction technique. If it was, the problem would pop back the minute you thought about it again. As long as you have dissolved the core issue driving the bad feelings, it won't.

Once the bad feelings have been neutralized, if there is any fear of it happening again, use the Code to dissolve that fear of the fear.

Also, understand that some issues have more than one piece or aspect to them. The Happiness Code is a very thought-specific technique, so if a perceived threat has more than one part to it, each part needs to be neutralized separately.

Addictive Urges
or Obsessive Behavior

Most addictive urges are triggered by anxiety, whether it is a low level anxiety like boredom or a high-stress issue. Our subconscious mind controls roughly eighty five to ninety percent of our daily behavior and it does it non-analytically and it does it with feelings.

We never get a feeling without a thought behind it first – usually it is a subconscious thought. We get a thought, then a feeling, then we react to the feeling. These "pushes" from the subconscious are based on associations from our past known as deep subconscious imprints. If we have something bad happen to us, our subconscious mind will remember it and put it in its files under, "we never want that to happen again." However, being a non-analytical process, it may also associate other things that were at or around the event as being part of the problem. It could associate with the kind of day it was – perhaps overcast or windy. Maybe it is the kind of furniture that was in the room or a song that was playing in the background. Then, from that time on our subconscious mind will associate any one of those associated elements as a threat. When those elements (weather, objects, sounds, smells) show up again in our

These "pushes" from the subconscious are based on associations from our past known as deep subconscious imprints.

life, our defensive alarm bells go off, thus triggering negative feelings.

The same thing happens for positive associations. If something we perceive as good happens to us, our subconscious mind will now associate that event and things around it with good feelings.

The addiction of smoking cigarettes is a good example of this subconscious associative process. Think about it. Not many people started smoking because they wanted nicotine. First of all, nicotine is not a mind-altering drug. It's a stimulant and a poison that smokers use to relax with. Relax with a stimulant? How can that be? As an ex-smoker myself, I remember being in stressful situations and thinking, "Man I need a cigarette." And even though on a physical level, smoking caused my blood pressure and heart rate to increase, I felt more emotionally comfortable smoking that cigarette.

To understand why, we can look back at the real reason a smoker starts smoking in the first place. What were we really looking for from cigarettes? What was the emotional payoff? Maybe it was to look older or tougher, to be cool, hip or sexy, and most certainly to be accepted by someone or some group that was important to us. In fact, any or all of those things were so important to us that we were willing to put ourselves through physical discomfort while learning to inhale smoke into our lungs without choking to death. The problem was that we got the payoffs. We *felt* cooler, tougher, sexier, and accepted. Bottom line, we felt more secure. Our subconscious mind now associates all of those positive feelings of security not just with nicotine, but with the whole idea of smoking.

That explains how we can *feel* like we are relaxing even though we are using a stimulant. When life is not perfect (and the more non-perfect it becomes), the more our mind

runs through our subconscious memory files looking for something it can associate with better feelings. It will then push us toward behavior that represents comfort and security, and it will do it with feelings.

Feeling compelled to eat even though we are not physically in need of food is another example of our mind associating a behavior or substance with comfort. As we try to ignore the feelings the stronger they become. This extra discomfort we feel will now amplify our need to eat. We get caught in a loop. The more we try not to eat, the more we feel a need to eat.

The more fear or anxiety we allow into our lives, the more vulnerable we are to addictive behaviors. The Happiness Code can help us break the loop and free us from this trap.

When I'm working with a client to end their smoking addiction, I ask them to think of never being able to smoke another cigarette ever, and then give me a number from one to ten describing their discomfort when thinking that thought, ten being panic and one being no bad feelings at all. Now, while thinking the thought of never smoking another cigarette, I guide them through the Happiness Code and once again check to see what number their discomfort level is. Sometimes they need to repeat the Code sequence until their discomfort is totally gone. Once they are completely comfortable with the thought of never smoking again, the use of additional techniques such as hypnosis or even cold-turkey commitments, have a much better chance of working with long term positive results.

The Code can also be used for urge control. Let's say a person is fighting an urge to smoke. While *thinking* of their discomfort about not smoking, they go through the Code sequence. In most cases their urge will dissolve. Since the addictive urge is a symptom of anxiety, a more

long-lasting relief can be accomplished by using the Code to dissolve the issue or issues that might be creating the anxiety in the first place.

To recap briefly, before using the Code just to dissolve an urge to smoke, eat chocolate, bite finger nails or some other obsessive need to do something, it is best to first think of never doing it again and use the Code to dissolve any discomfort with that idea.

DISSOLVING AN ADDICTIVE URGE – THE METHOD

Think of not giving in to your urge. Rate the discomfort you feel while thinking of it on a scale of one to ten, ten being the highest it can be, and one being no discomfort at all.

While you continue to think about what bothers you, use just *two fingers* and lightly touch each place on your body shown on the diagram on page 96. Touch each place for about *4 or 5 seconds*. Breathe normally while touching the points in the *exact order* shown by the numbers.

It doesn't matter which side of the face or body you touch. The points are duplicated on both sides. You can even switch hands during the sequence. Use either hand to touch each point 1 – 15.

Setup phrase of acceptance: Some practitioners think that it is important to always use a setup phrase of acceptance, some don't. I think it's a good idea to use it because it seems to help focus the thought pattern in the correct polarity to allow a positive change.

The setup phrase of acceptance is done by touching the #1 spot shown on the chart. I call it the reset point. It is located on the outer edge of the hand and is the point one would use to deliver a karate chop. While touching this

point you say your setup phrase of acceptance such as, **"Even though I have this urge to** (state what you have the urge to do), **I totally love and accept myself."** You don't have to believe your statement, just say it anyway. You then focus on your fear while touching the remaining points in the order shown.

(Note: Touching point #9 may be omitted most of the time. If you don't get relief, put #9 back into the sequence and try again. Point #9 is located one inch below the nipple on a man. For women it is where the under skin of the breast meets the chest.)

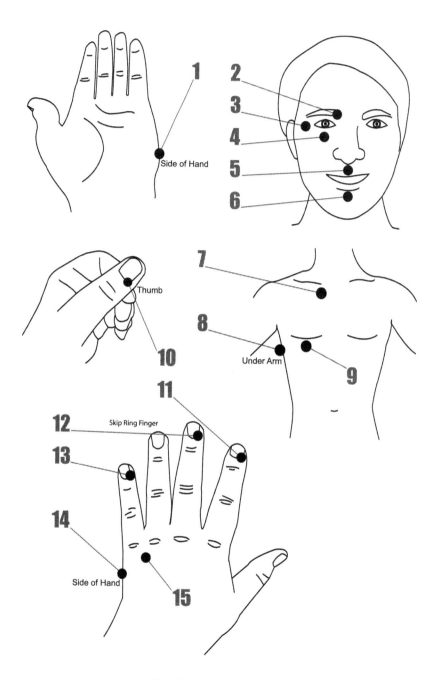

The Happiness Code Sequence

Now continue touching the #15 spot while you:

 a. Close your eyes and open them again;

 b. Move your eyes down and to the right and then down and to the left;

 c. (Still touching #15) Whirl your eyes in a complete circle;

 d. Whirl your eyes in the other direction;

 e. Stop eye movement, but keep touching #15 and hum a 5-second tune;

 f. Count to five out loud (1-2-3-4-5);

 g. Hum a tune again.

Again access the thought that was bothering you when you first started the sequence. The urge should be gone or lower. Feelings about the past issue should be more comfortable.

If the feelings are better but not completely comfortable, refocus on the problem thought and repeat the process.

Do not try to think positive or try to push the bad feelings away during the process. The upset feelings will dissolve on their own. It is not a distraction technique. If it was, the problem would pop back the minute you thought about it again. As long as you have dissolved the core issue driving the bad feelings, it won't.

Once the urge has been neutralized, if there is any fear of it happening again, use the Code to dissolve that fear of the fear.

Also, understand that some issues have more than one piece or aspect to them. The Happiness Code is a very thought-specific technique, so if a perceived threat has more than one part to it, each part needs to be neutralized separately.

"To truly learn, seek truth beyond tradition."

Creating Our Ultimate Emotional Comfort Zone – Dissolving Invisible Self-Limiting Conflicts

Welcome to the most important section of this book! As we have seen in the previous chapters, the Happiness Code is a great tool for dissolving the emotional conflicts that pop up in our daily lives. But if we really want to be at peace, and that does not mean to be in a place where there is no noise, no trouble or no hard work, it means to be in the midst of those things and still be calm and secure in our heart, then we need to dissolve away the invisible self-limiting conflicts of our past.

Let me first explain the difference between a *visible* self-limiting conflict and an *invisible* self-limiting conflict. A person who has returned from the horrors of war or perhaps is a victim of rape, or maybe someone who survived a terrible event such as 911 and exhibits signs of chronic anxiety, depression, or recurring nightmares could be categorized as someone with *visible* self-limiting conflicts. It is very easy to identify the cause and effect of their problem. Most therapists would label these individuals as having Post-Traumatic Stress Disorder (PTSD). The Happiness Code can be of great help to such victims.

All the other traumas, which by themselves don't drive us "over the edge into the great abyss," do mount up over time and they eventually take our stress levels to the

breaking point. These traumas are the *invisible* self-limiting conflicts. These are traumas that happened along the way in both our childhood and in our adult lives. They are the verbal, sexual, and physical abuses we suffered at the hands of others or maybe even the guilt we feel from having done hurtful things to others ourselves. There may have been times when we were ridiculed or teased and it made us feel worthless or inadequate. All of those times where we felt betrayed by a friend or family member, or became a victim of prejudice can be piled in there too.

All those times we felt wronged or judged less than, by ourselves or others, are all logged away in our emotional mind as traumas. All of the people, things, or events we were either taught to fear or learned on our own to fear or to dislike are stored there as well. They become our *invisible* self-limiting conflicts.

These are the emotional and physical traumas that we are told to just "get over and move on with our lives." We push them down and away out of sight. We try to convince

Unless we dissolve the guilt, hurt, anger, resentment, and fear, our energy is going to into repression and avoidance, not healing.

ourselves that we will be stronger for them. We force ourselves to just move on and forget about them. We accept the idea that "time heals all wounds." Well, no way Jose. I think it is more realistic to say that, "time masks some wounds." They may be repressed or tucked away for a while, but they're certainly not healed nor forgotten. They just get buried in our emotional mind –

with a landmine attached to each one. With the passage of time, even what we consider little problems mount up, one on top of the other until suddenly they become overwhelming in our lives. Only after we **dissolve** the guilt, hurt, anger, resentment and fear, can we say we are truly

stronger for it. Otherwise our energy is going into repression and avoidance, not healing.

Our perception of the present and future is determined by our past. All of the reasons we don't like ourselves or others, are products of our past. As I wrote earlier, everyone on the planet is suffering from a form of Post Traumatic Stress Disorder. Any fear, anger, resentment, anxiety, hurt or depression we feel today, or about our future, is fueled by our past.

It is also becoming apparent that many of our physical ailments and addictions are caused by or at least contributed to by unresolved traumas, guilt, shame, anger, grief and so on. This includes everything from headaches, digestive and breathing disorders, irritable bowel syndrome, fibromyalgia, chronic fatigue syndrome, as well as other serious maladies such as multiple sclerosis and cancer. Most medical doctors agree that emotional stress contributes to or exacerbates many serious physical diseases. Using the Happiness Code to dissolve our emotional cancers translates into less internal conflict. Fewer invisible self-limiting conflicts translate into higher levels of personal peace with less emotional and physical suffering.

Remember, just because we survived our past doesn't mean we are stronger for it. All of that hurt and all of the effort to keep the lid on the "trash can" of our past, keeps piling up and spilling into our present and into our future. The only way we can be truly stronger is to ***empty the trash***. Just think what we could accomplish if we weren't using so much of our energy to keep the lid on all that junk. We would be free at last! Thank God Almighty, we'd be free at last!

THE PROCESS OF DE-JUNKIFICATION - DISSOLVE BOTH VISIBLE AND INVISIBLE SELF-LIMITING CONFLICTS

One of my clients whose name is Deb, coined the process of going back through her life using the Happiness Code to dissolve past traumas as *de-junkification*. She marveled at how quick and easy it was, using the Code, to dissolve an emotional upset caused by a past traumatic incident. The most difficult thing seems to be getting people to try it.

What is it about us humans that makes us want to hang on to our "stuff?" Most of us, if we were guided through it, would try this technique to dissolve one *visible* self-limiting conflict and say, "Wow, that's better!" But, most would then go on with our dysfunctional emotional lives, blaming other people or events for our discomforts and whining about how stressed we are because of this or that. I even know therapists who, although they are trained how to use the Happiness Code to help others, don't use the Happiness Code for themselves. These therapists are still doing the "woe is me" routine. I guarantee that not one of them has ever spent even an hour of their life to dissolve the past stuff that is driving their current upset or stress. When they complain to me about their lives, I remind them that they could use the Code to fix it, and I hear, "Oh yes, I guess I could." Then they go right back to trying to fix everyone else instead of themselves.

WHO NEEDS TO DE-JUNKIFY?

It's amazing how many people think that they are not in need of de-junkification. It's funny. Many such people are already taking a pill for anxiety, depression, or some sleeping disorder. In fact, ***over forty-two million*** people in the U.S. are taking sleeping aids of some kind. It isn't our jobs, kids, spouses, mothers, fathers, brothers, sisters, or co-workers that are the problem. It's us! ***They*** won't change until we do.

I suppose that dissolving the triggers that keep us stressed and unhappy is scary to some. After all, who would we be without our pain? But when we use our pain to justify our anger and resentment we bond ourselves to the wounds of our past. We make our wounds and our pain who we are – our drama. Many people confuse this drama with passion. We all know drama queens and kings in our lives. What we might not be aware of, is the drama queen or king staring back at us while we're looking into a mirror.

Before we move on, let's clear up some possible misconceptions. Using the Happiness Code to dissolve negative emotions does not, I repeat, does not make us an unfeeling person. What it does is give us more room for positive feelings. Releasing fear, anger, and hurt from our past with the Code will allow us to relate to the world we live in on a much higher plane. Without fear, anger, and hurt blocking our view, it will be easier to see ourselves and others through the eyes of love, understanding, and forgiveness. We will have a safe place within ourselves as an anchor and as a point of reference for our future actions.

Using the Happiness Code to dissolve negative emotions does not, I repeat, does not make us an unfeeling person.

Remember, when we change the way we look at things, the things we look at change. Since the way we look at things is filtered by our past, if we feel better about our past then our present and future will take on a whole new look.

So, please!! Don't just give this book to someone else because "you're okay, but they're not so hot." Do yourself and the rest of the world a favor, use the Happiness Code and de-junkify.

THE DE-JUNKIFICATION OF GARY

De-junkification begins with our own desire to change. We can try to make all the other billions of people on the planet change to suit us and no longer push our buttons, or we can try to change just one person (ourselves) by eliminating our buttons. So, which might be the more sensible way to go? That's right, start with "me."

Several years ago when I was first introduced to an earlier version of the Happiness Code, known then as Thought Field Therapy, I decided to see if this strange new method could help me feel better about my past so that I might then feel better about my present and future. After all, the process seemed easy enough (almost too easy) and I could do it in complete privacy, not having to divulge or explain my inner most secrets and feelings to anyone else who might judge me.

Living and reacting in fear had become familiar territory to me. As a young child, my father abandoned me, and to this day I have no idea where he went. He's probably dead by now. Due to the social and financial strain this put on my mother I was sent to live in various homes, some were loving homes, some were not so loving. By the time my mother remarried and we were reunited as a family, I was well entrenched in a fear of abandonment, along with anger, low self-esteem and control issues that I harbored right into my adult life.

A wise person once said, ***"We are not responsible for what happened to us as a child, but we are responsible for how we handle ourselves as an adult."*** So it was choice time for me. I could continue blaming my past and others for my broken marriages and the turmoil in my life, or I could accept the true fact that it is not them that need to change. It's ME.

It is always easier to blame others for choices we make that don't turn out the way we want, rather than to accept the fact that we make the choices that rule our lives. Even if we make the choice to give others the power to choose for us, it is still our choice to give them that power. For me, it was time to stop blaming my past on someone else and take responsibility for my present.

So with all that in mind, I decided to begin the de-junkification of me. The first thing I did was to make a list of all the past traumas I could remember, which may not be the best way for some people to start the process, but we'll talk more about that in a moment. I started with the very earliest trauma I could remember, which was being lost in a grocery store at the age of three and a half or four years old.

Even as an adult, when I thought back about that incident with myself as that panicked little guy, tears running down my face as I ran from isle to isle fearing I was suddenly alone in the world, I would still feel the fear. Since my father had left when I was two and my mother couldn't afford to keep me, the groundwork for my fear of abandonment had already been laid.

Systematically, as I came forward through the years of my past, I tried to focus on any memories of situations where I remembered being afraid, angry or embarrassed, and / or times I had been teased, ridiculed or rejected. I also included situations when I suffered a loss, and even things I felt guilty about having done or not done. The list consisted of just a word or a short sentence for each situation to remind me of each particular incident as I went back through the list. Then, using the Code sequence, starting at the beginning, I went through my list, dissolving each trauma one by one.

Not all of my negative childhood memories triggered any noticeable bad feelings when I thought about them in

the present. But I knew these memories were still active because the effects of them were noticeable in my current behavior. They needed to be dissolved also. For instance, when I was in grade school the teacher called me up in front of the class to solve a math problem she put on the chalk board. I remember facing the board – chalk in hand – realizing that I had no clue how to solve the problem. I could feel the eyes of my classmates on the back of my head. The teacher got angry with me. I remember my ears feeling hot as my face flushed with embarrassment. As I shuffled back to my seat with my eyes glued to the floor, I knew that everyone thought I was stupid. Today, looking back on that incident, I am sure that it was the reason I hated math from that moment on. My defense mechanism had been to close my mind to math. Thus, a learning disability was born.

Since the Happiness Code is a very thought-specific technique, it was very simple to think of a past event, acknowledge the feelings associated with it and then, using the Code, dissolve those bad feelings away forever. Each event took me only thirty to sixty seconds to dissolve any upset feelings that had been attached to the issue. It didn't erase the memory of the event, just the negative emotional feelings that had been attached to it. Each past issue soon became, "been there, done that," and was no longer an emotional threat.

"Each event took me only 30 to 60 seconds to dissolve any upset feelings that had been attached to the issue."

After completing my trek down memory lane, I felt lighter both emotionally and physically. I wondered if it was just placebo effect, but then I remembered that going into it, I really thought it would probably just be a silly waste of my time. Yet now, when I thought of any of those past traumas, there was no upset at all. In fact, I even had

trouble focusing my thoughts on some of them. Later on, I discovered that this is a common phenomenon of a dissolved self-limiting conflict.

Over the next couple weeks, I had four people, all who knew me well, ask what was different about me. I didn't think much about it after the first comment, but when the second one asked pretty much the same question I had to stop and ask, "What do you mean by different?" He said, "I don't know. You just seem more mellow or happier."

The next two people both said basically the same thing. They stated that I seemed to be smiling more and not sweating the small stuff. Well, I wasn't on any mood altering dugs. The only thing I had done to account for this positive change in my attitude was to dissolve some past traumas with the Happiness Code. I realized then that this is not a belief system working here; it's just the ability to manipulate our own bio-neuro-energy alarm system for our benefit.

Once I became aware of the immense positive impact that dissolving a few of my past traumas had on my emotional and physical well-being, I decided to put a little more thought into the process. Since my first *de-junkification list* only consisted of about twenty five items, I knew there had to be a bunch more that were still constricting my emotional comfort zone. I concluded that it was not just childhood stuff, but a whole lot of adult junk still fouling up my system. I found that by remembering some of the good times in my past I could travel back more comfortably to some of the not so good times that occurred at the same age or with the same people. My list began to grow. Before I finished, I listed another thirty-five or forty items to dissolve. Over the years I've dissolved well over a hundred more.

MAKE A DE-JUNKIFICATION DIARY

Even though it worked for me, I no longer recommend the "make a list" method. For some people just the thought of making a list could overwhelm them, so then they would avoid it altogether. For others, the process of bringing up so many traumas one after the other, without dissolving each one first, could become overwhelming. So instead of making a list of things to dissolve, I recommend making a diary or list of the things you dissolve as you go along. In other words, you think about just one past trauma. You then write a few words down in your de-junkification diary, which will remind you of the issue and use the Happiness Code to dissolve it. Then try and remember another upset from your past, put it on your list and dissolve it. Before you know it you will have a diary of all that stuff you have dissolved. My diary would have started with "lost in grocery store age three and a half." Yours might start with "wet the bed with my sister in it, age five." As we know, everyone has their own stuff.

Remember, some issues will have more than one piece or aspect to them. Be sure to dissolve each one to get total relief. Making a de-junkification diary will help keep track of your progress and allow you to go back over your list later to make sure all aspects of each issue have been dissolved. You may also find that going back over your diary will jog your memory of other junk which needs to be dissolved. I have provided a few pages in the back of this book (p. 169) that can be used for your de-junkification diary if you wish.

WITNESSING AN EVENT CAN PRODUCE THE SAME FEAR RESPONSE AS EXPERIENCING IT

I think at this time it is worth restating the fact some of the things that our mind logs away as a threat actually did not

happen to us. A New York University study (Dec. 2004) showed that witnessing a traumatic event can cause the same fear response as if we had experienced it ourselves. When I watched the towers go down on 9/11, like most of us I was affected on a deep emotional level. Even though I wasn't there but was only watching it on television, I still felt strong emotional pain, sadness and anger. This terrible event did not happen to me or any of my loved ones, yet as I watched the news coverage, the feelings were almost unbearable.

I can only imagine the pain of those who lost someone close to them during 9/11 and then had to endure seeing the news footage over and over again. I used the Happiness Code to help me through the feelings 9/11 generated within me. It didn't make me joyful, but it took any need for anger and revenge out of the equation. I hoped God would forgive them for what they had done and forgive us for not caring enough about the things that were so threatening to them that they felt a need to kill themselves and others to make their point. I urge everyone to use the Code and put 9/11 in their de-junkification diary.

I urge everyone to use the Code and put 9/11 in their dejunkification diary.

LET BAD FEELINGS FROM THE PAST DISSOLVE AND FADE AWAY

Starting the process: There really is no right or wrong way to start the process of de-junkification. Just dissolve the first trauma that pops into your mind, whether it happened yesterday or fifty years ago, write it in your diary, and go from there. You might simply ask yourself, "What memory would I rather not have." Gary Craig starts by asking, "If you could live your life over again, and there were something or someone in your life you would just as

soon skip, what or who would it be?" Remember, using the
Happiness Code to dissolve a past trauma doesn't erase the
memory of the event. What it does is neutralize any bad
feelings that had been attached to that memory.

If you suffered a recurring trauma, such as abuse of
some type, then it is best to go back to your first memory
of it happening and dissolve that first, then come up
through history dissolving the upset attached to each
memory that still bothers you. By starting with the
earliest or root cause of the upset you may find that it has
a domino effect of dissolving the similar traumas that
came after without you having to go through each one
dissolving them separately. By dissolving the root cause
first, it will take away the driving force behind the more
recent memories of the same abuse.

BUT I DON'T WANT TO THINK ABOUT IT

If you feel some resistance or anxiety about going back
in your past, even for a brief moment, then dissolve the
"going-back" fears first. While thinking about the process of
going back, rate your anxiety about it on a scale of one to ten
(ten being high anxiety, and one being virtually no anxiety
at all). While touching the #1 point as shown on the chart,
say, "Even though I have this fear of thinking about my past,
I totally love and accept myself." Then use the Happiness
Code sequence and dissolve the anxiety you have about
thinking back. Once the anxiety about the process of de-
junkification is gone, the idea of becoming free from the
bondage of old wounds becomes exciting.

If you are afraid of being totally overwhelmed if you
were to vividly imagine a certain terrible past trauma, then
you might try a technique that I learned from Gary Craig.
Without taking yourself back to the event, give the past

incident a title, such as "the time my father punched me when I was 12." Write the title down in your de-junkification diary. Now, just guess how strong you think your emotional upset might be, on a 0 to 10 scale, if you had to vividly imagine the incident. Write that number next to your title. Once you've done that, begin the Happiness Code sequence and as you touch each point, say to yourself, "this father-punch emotion." After completing the sequence, make another guess of how high you think your emotional upset might be if you had to vividly remember the incident. Repeat the process until the number you would guess is low. Now vividly imagine the past incident while going through the Code sequence. In most cases any remaining upset will be dissolved.

WHAT IF I DON'T REMEMBER MUCH OF MY CHILDHOOD?

Some people tell me that they don't remember much about their childhood. There are generally only two explanations for such a statement. One, and the most common, is that they haven't really put much thought or effort into the process of remembering. The other is that they may be repressing these memories because they are much too uncomfortable to remember. If we really try, most of us can remember enough stuff that needs dissolving to make a positive difference in our lives.

"Fear is the absence of love."

De-Junkification Memory Joggers

To help facilitate the recollection of past issues that need to be dissolved, the following list of lines and phrases might serve as memory joggers. They may strike a chord as they are, or remind you of a similar situation which you experienced. This list is by no means meant to be a totally comprehensive one. It is not presented in any particular order. Everyone has their own stuff, but we can sometimes be surprised at how similar our stuff can be to that of our fellow human beings.

JOGGING CHILDHOOD MEMORIES

NOTES:

1. **A time when lost in a store, or in the woods, in an amusement park, in a strange neighborhood or some other location.** *(Feelings of disorientation, panic, or abandonment can be lasting and become compounded through the years greatly influencing our behavior in adult relationships. We may become easily anxious, jealous or mistrustful.)*

2. **A time when you were ridiculed or laughed at while trying to learn something new, such as riding a bike or playing a sport.** *(If we have trouble getting ourselves to try new things or learn new skills, it may be rooted in one or more such occurrences.)*

3. **A time when you were injured in an accident, perhaps broke a bone or suffered a cut that needed stitches.** *(Such an occurrence can contribute to a phobia. If a person fell out of a tree or maybe off a ladder or building, they may develop a fear of heights. They might develop trust issues or even fears associated with the medical personnel or procedures that they came in contact with as a result of the accident.)*

4. **A time when you accidentally injured someone else.** *(Guilt can be the cause of all sorts of mental and physical problems. Self punishment has lasting effects.)*

5. **A time when you physically or verbally injured someone else on purpose.** *(Even if we can justify the action as self defense, the guilt or trauma of injuring others can be lasting.)*

6. **A time when you were bullied, physically or emotionally.** *(Such occurrences can make lasting scares on our self esteem and can also contribute to chronic anxiety, anger, and control issues.)*

7. **A time when you were teased or ridiculed about your appearance by someone in your family. Your clothing, hair, body type etc.** *(Certainly a blow to your self esteem can cause chronic anger and anxiety, and might even send a person looking for love in all the wrong places.)*

8. **Times when you were afraid or physically hurt in medical situations, such as the hospital, doctor's office, dentist office.** *(Can contribute to lasting fears or phobias and trust issues, as well as avoidance of needed medical attention.)*

NOTES:

NOTES:

9. **A time when you had to move away from your neighborhood into a new one. Saying goodbye to friends.** *(Contributes to feelings of anxiety, loss or grief, and future avoidance of becoming close to anyone.)*

10. **A bad experience when starting at a new school, finding your way around, or meeting new people.** *(Could make you wary of going new places by yourself, starting new job, etc. Could even contribute to social anxiety disorder.)*

11. **Times you may have experimented sexually *with a friend or family member.*** *(Can cause lasting guilt, and sometimes contribute to unhealthy sexual attitudes.)*

12. **A time you shoplifted or stole someone else's property.** *(Lasting guilt, or low self esteem caused by judging yourself poorly.)*

13. **A time you flunked a class in school.** *(Can cause anger and low self esteem by you judging yourself, or others judging you as not good enough or smart enough. Can contribute to learning disability.)*

14. **A time a pet you loved, died or was killed.** *(Can cause lasting grief or pain, and compound the pain of any such losses that follow.)*

15. **A mean or nasty teacher that told you that you were stupid and would never amount to anything.** *(Can cause lasting anger and contempt for authority, or low self esteem and lack of any desire to achieve.)*

16. **A time when a family member embarrassed you in front of your friends.** *(Causes low self image and feelings of rejection, also creates trust issues.)*

17. **A time when you were spanked by one of your parents.** *(Can contribute to fear, anger and problems with authority figures, as well as self esteem and trust issues, along with the notion that might makes right.)*

18. **A time you were slapped, hit, punched, or kicked by a parent or someone else.** *(A real blow to self esteem – no pun intended. Causes strong and lasting feelings of anger*

NOTES:

and rejection. Fear of, or anger at authority figures. May learn to react to stressful situations with violence. I have found that many alcoholics have experienced being kicked or punched by a parent.)

19. **Times you felt alone, rejected, unloved and misunderstood.** *(Contributes to low self worth, depression, and anxiety)*

20. **Times you felt, fear, anger, or resentment about your parents getting a divorce.** *(Can create lasting, anger or resentment toward one or both of your parents – perhaps feelings of guilt that you were the cause. Also feelings of abandonment and trust issues.)*

21. **Anger about a divorced parent's new boyfriend or girlfriend.** *(Can contribute to feelings of abandonment, jealousy, and lasting anger and resentment toward the parent)*

NOTES:

22. **Anger or fights with a step parent or foster parent.** *(Can cause feelings of abandonment, low self esteem, rejection, lasting anger and resentment toward both step, foster, or biological parents.)*

23. **The death of a loved one.** *(Can cause everything from lasting grief to feelings of anger and betrayal.)*

24. **A breakup with a boyfriend or girlfriend.** *(Can cause lasting feelings of grief, anxiety, anger, betrayal, guilt, resentment, combined with jealousy and lack of trust in future relationships.)*

25. **Times when you were forced to stand up in front of others and speak, even though you were afraid to do so.** *(Can contribute to low self esteem and compound a fear into a phobia.)*

26. **Times when you were disappointed in yourself or others.** *(Contributes to ongoing guilt or anger, also sets up lack of trust issues in yourself or others.)*

NOTES:

27. **A time when you found out you had been betrayed or lied to.** *(Causes lasting pain and anger along with negative trust issues with those involved and even people you haven't met yet.)*

28. **A time you were sexually abused by a family member or someone else.** *(Causes everything from feelings of anxiety, anger, resentment and betrayal, to feelings of guilt, low self esteem, and unhealthy sexual attitudes.)*

29. **A time you were screamed at and verbally abused by a family member or someone else.** *(Causes anger, resentment, low self image.)*

30. **The time a parent told you they wish you had never been born.** *(Usually contributes to feelings of abandonment, anxiety, and low self worth.)*

31. **A time you were told that you were no good.** *(Causes low self worth.)*

NOTES:

32. **Times you watched your parents fighting.** *(Contributes to ongoing fear and anxiety, along with guilt and fears of abandonment.)*

33. **Any mistake or mistakes you feel guilty or embarrassed about.** *(Obviously causes guilt and low self esteem and may contribute to anxiety, and a resistance to trying new things.)*

34. **Memories of one or both of your parents being intolerant about a particular race or religion.** *(Can contribute to your fear of, or intolerance about that particular race or religion, or in my case it caused anger and a lack of trust in my parents' judgment about anything.)*

35. **Times when you tried new things and failed.** *(Can cause poor self image and a low desire to achieve.)*

36. **Times when you lost a game and were ridiculed by the winner or others.** *(Can cause self esteem issues, anger and resentment along with a need to always win or be right.)*

NOTES:

NOTES:

37. **When you were forced to eat foods you hated.** *(Can cause ongoing resentment and anger along with a need to control others.)*

38. **Bad things that happened, on the way to, or the way home from school, while walking or riding a bus.** *(Cause of all kinds of fear, anger, and resentment, along with self esteem problems, learning problems and control issues.)*

39. **Bad or uncomfortable things that happened while away at camp.** *(Could contribute to feelings of guilt, rejection, low self esteem, anger and more.)*

40. **Uncomfortable or embarrassing times in the school locker room or shower.** *(Can contribute to anxiety, anger, resentment, low self esteem and poor body image.)*

41. **Times you performed poorly in sports or gym classes.** *(Can cause poor self image, and a lack of desire to try to improve, or could push you toward over achieving and a need to win at any cost.)*

42. **A time you almost drowned or someone bigger than you held your head underwater.** *(Could cause low self esteem, anger, fear and anxiety, or maybe a need to control others with violence.)*

43. **A time you were sick or injured and no one seemed to care.** *(Could cause feelings of abandonment, low self worth, or feelings of being unlovable.)*

44. **Birthday or holiday disappointments.** *(Contributes to feeling rejected, worthless, or misunderstood.)*

45. **Being thrown out of the house.** *(Causes lasting anxiety, anger, resentment, low self esteem and more.)*

46. **A time when you ran away from home.** *(Why did you run? Was it because of fear, anger or what?)*

47. **Awkward first sexual experience.** *(Could be the cause of sexual anxiety.)*

NOTES:

48. **A time you were falsely accused of doing something wrong.** *(Could cause lasting anger, resentment, and even guilt.)*

49. **A time you were threatened by weather, tornado, hurricane, lightning, etc.** *(Causes lasting fear and may become a phobia.)*

50. **A major verbal or physical fight with a sister or brother.** *(Contributes to lasting anxiety, anger and resentment.)*

NOTES:

ADULT MEMORY JOGGERS - (18 years and up)

NOTES:

1. Time you were told you were no longer welcome in your parents home.

2. First days away at college.

3. First days of military boot camp.

4. Rejected by the college of your choice.

5. Rejected by a fraternity or sorority.

6. Rejected by someone you asked for a date.

7. Not getting the job you really wanted.

8. (Military) Fear you felt before going into battle.

9. (Military) Being in battle, bullets whizzing by, explosions, confusion, chaos.

10. (Military) Seeing comrades injured or killed.

11. (Military) Killing or injuring others in combat.

12. (Military) Being injured in combat.

13. Being passed over for a promotion at work.

14. Being fired from your job.

15. Being told your child has a serious illness.

16. Loss of a child through violence, accident or illness.

17. Death of a close friend.

18. Death of a spouse, parent, sister, brother or other close family member.

19. Time you were arrested.

20. Time you went to jail or prison.

NOTES:

21. Time you were told you had a life threatening disease.

22. Loss of a pet you loved.

23. Time you were yelled at or ridiculed by a boss in front of co-workers.

24. Loss of home or possessions due to weather, or fire.

25. Loss of home due to foreclosure.

26. Business failure.

27. Time when you were betrayed by a co-worker, friend or loved one.

28. Time you were cheated on by boyfriend, girlfriend, or spouse.

29. Divorce or breakup of a relationship.

30. Automobile, motorcycle, or other major accident.

NOTES:

31. Victim of a crime such as rape, robbery, or other assault.

32. Victim of a crime on your possessions such as home or auto burglary.

33. Children in trouble with the law or at school.

34. Guilt about not living up to religious standards.

35. Witness to any terrible event, in person or on television, such as 9/11.

36. Physical or emotional abuse by a spouse.

Plus others not mentioned here...

NOTES:

The lists are designed just to get you started. Some of the traumatic events you remember may not trigger noticeable emotional upset when you think about them now. Do not, and I can't stress this point enough, DO NOT just ignore the memory and go about your business. From experience as a therapist, I can say that, in most cases, the issue is still controlling your behavior in negative ways. That's why I call them "invisible" self-limiting conflicts. They are there, but we've simply gotten used to the pain. The conflict still exists, but our tolerance for it is higher. As I've said before, "time does not heal all wounds, it only masks the pain."

If you remember an event that caused you emotional upset at the time it occurred, but little or no upset now, just try to remember how you felt when it happened. With that memory in your thoughts, go through the complete Code sequence at least once. It could turn out to be the most important forty to sixty seconds of your life!

LEVELS OF PARTICIPATION

Review again the different levels of participation that participants in the Happiness Code will likely choose. Then decide what you are going to do.

THE FOUR LEVELS OF PARTICIPATION WITH THE HAPPINESS CODE

1. **Total Rebuke** – You read the material, but because of the fear of change and of new ideas you decide to dismiss it: "I don't believe a word you said." *(You can't be bothered by truth.)*

2. **Light Curiosity and Interest** – You read the material and find it interesting, and you find an

immediate benefit for others beside yourself. "These are pretty good ideas and methods. I know I don't need it, but I know some other people who really could use it." *(You're already perfect.)*

3. **Light Experimentation** – You lightly review the contents and try out a few techniques half-heartedly. At the first difficult moment, at the first sign of frustration you drop it. Or, you may even dissolve a single fear or phobia and then stop. "Well, I think I've gotten enough from this." *(If I can't change my whole life in just sixty seconds of thought and effort, why bother to continue.)*

4. **A Commitment to Change** – You read the material and decide to complete the entire process of self-improvement. You commit yourself to learn and utilize the techniques of dissolving your Invisible Self-Limiting Conflicts. It takes you a little longer, but you pay attention to the instructions I give you. You may only dissolve a few fears each day, but you keep going. Soon you begin noticing differences in your behavior. Others notice it too. You no longer just react to life. You seem to have greater freedom of choice. You notice greater peace and contentment. Then you begin to get excited about the effectiveness of the Happiness Code. "Wow, this is amazing!" *(You are a proactive person who is always open to new ways of improving yourself.)*

A GOOD CHOICE! If you chose the fourth level of participation, good for you, good for your family, good for your friends, good for your co-workers, good for the world we live in and good for the universe. You will no longer have a need to buy into drama, neither yours nor anyone else's. You can become a comfortable observer of the Play instead of a character in it. And if you choose to be dramatic it will be positive drama.

DE-JUNKIFICATION – THE METHOD

Clearing out a lifetime of visible and invisible self-limiting conflicts!

Think of something in your past that gives you bad feelings when you remember it now. Rate the discomfort you feel while thinking of it on a scale of one to ten, ten being the most uncomfortable and one being no discomfort at all.

While you continue to think about what bothers you, use just *two fingers* and lightly touch each place on your body shown on the diagram on the following page. Touch each place for about *4 or 5 seconds*. Breathe normally while touching the points in the *exact order* shown by the numbers.

It doesn't matter which side of the face or body you touch. The points are duplicated on both sides. You can even switch hands during the sequence. Use either hand to touch each point 1 – 15.

Setup phrase of acceptance: Some practitioners think that it is important to always use a setup phrase of acceptance, some don't. I think it's a good idea to use it because it seems to help focus the thought pattern in the correct polarity to allow a positive change.

The setup phrase of acceptance is done by touching the #1 spot shown on the chart. I call it the reset point. It is located on the outer edge of the hand and is the point one would use to deliver a karate chop. While touching this point you say your setup phrase of acceptance such as, **"Even though I have these bad feelings about** (state what you have the bad feelings about), **I totally love and accept myself."** Or you might say, "even though I have this anger about..." or "even though I have this guilt about..." Then state the issue followed by your affirmation of self

acceptance. You don't have to believe your affirmation, just say it anyway. You then focus on your fear while touching the remaining points in the order shown.

(Note: Touching point #9 may be omitted most of the time. If you don't get relief, put #9 back into the sequence and try again. Point #9 is located one inch below the nipple on a man. For women it is where the under skin of the breast meets the chest.)

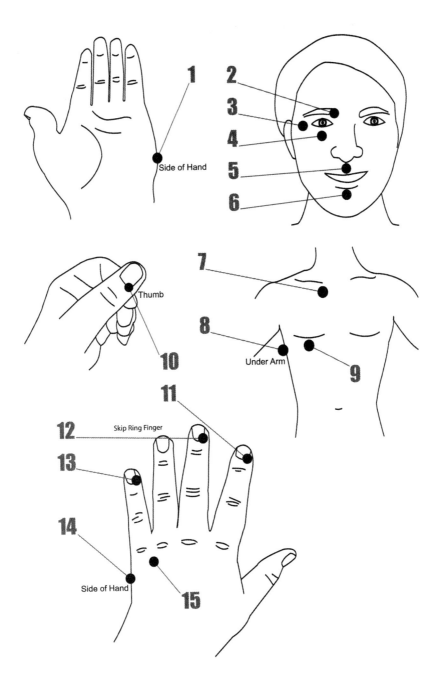

The Happiness Code Sequence

Now continue touching the #15 spot while you:

a. Close your eyes and open them again;

b. Move your eyes down and to the right and then down and to the left;

c. (Still touching #15) Whirl your eyes in a complete circle;

d. Whirl your eyes in the other direction;

e. Stop eye movement, but keep touching #15 and hum a 5-second tune;

f. Count to five out loud (1-2-3-4-5);

g. Hum a tune again.

Again access the thought that was bothering you when you first started the sequence. The upset should be gone or lower. Feelings about the past issue should be more comfortable.

If the feelings are better but not completely comfortable, refocus on the problem thought and repeat the process.

Do not try to think positive or try to push the bad feelings away during the process. The upset feelings will dissolve on their own. It is not a distraction technique. If it was, the problem would pop back the minute you thought about it again. As long as you have dissolved the core issue driving the bad feelings, it won't.

Once the bad feelings have been neutralized, if there is any fear of it happening again, use the Code to dissolve that fear of the fear.

Also, understand that some issues have more than one piece or aspect to them. The Happiness Code is a very thought-specific technique, so if a perceived threat has more than one part to it, each part needs to be neutralized separately.

The De-Junkification of the Workplace

Unfortunately most people are not as happy in their work environment as Snow White's seven dwarfs were, and they don't really care to "whistle while they work." Why is it that we come home from work stressed to the max, instead of invigorated and positively charged with a satisfied sense of accomplishment? Why do we find it difficult to get along with some co-workers, bosses, managers, people we manage, or even the people our company sells to or services? Why do we feel anger, intolerance, resentment, frustration, intimidation, or depression?

It must be all *their* fault, right? WRONG! It is because we have been programmed to react in fear. Everything we automatically judge as a threat today is a product or our past associations and perceptions of things or situations that we interpreted as a threat some time ago. Anger, resentment, intolerance, anxiety, and a need to control, are all products of fear.

Listen to the self-righteous blame games we play. If "they" weren't so hard to get along with, everything would be fine. If Bob would wear a shirt that fit better, or Betty would dress in a more business like fashion, or Jenny would stop talking about her kids, or the boss would speak softer and listen to my ideas. We hear ourselves say things like, "they all just drive me right up the wall!" But the truth is,

when we utter such words, we are dumping the responsibility for our anger, intolerance, resentment, or depression, on them, instead of where it really belongs, which is with ourselves. We think that if all "their" behavior, which we judge to be problematic, and the cause of "our" emotional distress would just dissolve away, our life would be so much more comfortable.

Why are we so threatened by other people's mannerisms or quirks anyway? Have you ever said or heard someone say, "I don't know why, but I just can't stand that person." What is it that we find such a threat to our well being? It might be the way they carry themselves, with upright shoulders, or a little hunched over.

> *What are the chances that all those people in our professional lives will change their behavior just to suit our particular comfort zone?*

Maybe it's the way they walk – fast, slow, or with a limp. Perhaps the way they talk – slow, fast, or with a regional or foreign accent. It might be the tone quality of their voice – high and nasally or low and raspy. Could it be the way they are dressed in baggy pants or a tight and tailored look? Why are we so threatened by other people's choices and mannerisms that we feel such a driving need to control them into little "same as me" robots, rather than celebrate, or at least comfortably tolerate their differences? It's all about our past! The pain of our past also spills over into our professional lives. We are just *reacting* to life instead of choosing how we want to respond to it.

So what are the chances that all those people in our professional lives will change their behavior just to suit our particular comfort zone? How about zero chance? What if there was a way to change our reaction to their "stuff," so that we no longer reacted to it with defensiveness and negative emotion(s)? There is, and I call it The Happiness

Code. When we become more comfortable, the people around us will also be more comfortable. So, a more comfortable work place starts within us, not them.

DISSOLVING FEAR IN THE WORKPLACE

For many years, companies have been using fear as the main motivator for productivity, constantly threatening workers with losing their jobs unless they work harder, longer, and faster – constantly using destructive criticism and intimidation while setting one employee against another.

Such business models are huge contributors to the ever growing population of anxious paranoid pill poppers in this country. Yet there is a light at the end of the tunnel, and no, it is not a train coming the other way. It is a new breed of entrepreneurs who seem to be connected to the computer industry in one form or another. They have created businesses that employ thousands of people who actually look forward to going to work.

They've done it by simply treating their employees with the same kindness and respect that they would want for themselves. You know, "Do unto others as you would have them do unto you." (Well maybe God is smarter than some people gave him credit for after all!) They've done it by giving them a comfortable work environment both physically and emotionally. These computer wiz kids have done it through positive leadership, inspiring workers, giving creative authority via delegation, and rewarding the loyal effort of team members with appropriate recognition. Don't just take my word for it. Look on Wall Street and you'll see that these companies are reporting fantastic earnings. It is reported that in the Bible, Jesus said, "The *meek* shall inherit the earth." Maybe he meant the *geek* shall inherit the earth.

The success of such work environments are a great example of what I have been saying to companies for years, when you ***lower the fear*** in the workplace, you will ***increase productivity***.

USING THE HAPPINESS CODE IN OUR JOBS AND CAREERS

When workers are outside of their comfort zone, productivity suffers. Many of those who are considered Gurus in the "How to be a success" business, preach that to be successful in business, we must be willing to push beyond our comfort zone. Such an idea is ludicrous.

In my book, being a success is all about being comfortable – being comfortable enough to take risks, knowing that even if we fail we will survive and be wiser for it. Think about it. If we have to be in a place beyond our comfort zone, we certainly aren't comfortable. How can we expect to perform our best over a long period of time while constantly fighting discomfort and

Trying to become successful and happy by building up our tolerance for pain is an exercise in futility.

misery? That discomfort and misery then spills over into the lives of our employees and co-workers, as well as to their families and friends.

Success does not have to be painful! Trying to become successful and happy by building up our tolerance for pain is an exercise in futility. Being willing to make ourselves uncomfortable to attain a goal will just make us a masochist not a successful person. Truly happy, successful people don't have to force themselves to do things that make them uncomfortable. Instead, these are the people who are already comfortable doing the things that may make others

uncomfortable when they do them. So the key to success and happiness is not in pushing beyond your comfort zone. It is in Expanding Your Comfort Zone.

Using the Happiness Code to dissolve both our visible and invisible self-limiting conflicts is the key to positive, lasting changes in the expansion of both our personal and business comfort zones.

EXPAND YOUR COMFORT ZONE - A FOUR-STEP PROCESS

In my corporate business seminars I teach clients how to do just that – "Expand Their Comfort Zone." That's why I call it "Comfort Zone Training." It is a four-step process.

The first step is helping a person to comfortably dissolve their Visible Self-Limiting Conflicts such as a fear of public speaking, fear of test taking, fear of flying, fear of heights, fear of elevators, etc., any one of which could cause problems in business.

The second step is helping a person become aware of their own Invisible Self-Limiting Conflicts, those past conflicts that contribute to fear of success, fear of failure, fear of asking for the sale, and a host of other emotional shackles that keep us anchored to our past. These conflicts block the path to our highest levels of achievement.

The third step is to understand the science and mechanics of those conflicts and to dissolve them forever.

The fourth step is to provide a tool that will eliminate future fears and conflicts. It's a powerful, new way to redesign our thoughts so that we will automatically begin to move up the pathway of success and even beyond that of other top performers.

In earlier chapters, I have already outlined the process of step one through three. Now let's explore step four,

using the Happiness Code to dissolve both present and future conflicts between, supervisors, managers, employees, and colleagues.

DISSOLVING PRESENT AND FUTURE CONFLICTS IN THE WORKPLACE.

Most people have had the uncomfortable experience of dealing with a difficult co-worker or family member. I'm talking about the kind of person who is so difficult to deal with that the mere thought of having to be around them much less work with them, makes us shudder.

You know who I mean; this is the kind of person who really gets under our skin for one reason or another. Maybe they are always saying negative things behind people's backs, or even to their faces. They might be the type that is always whining about the job, the boss or other workers. Maybe they're messy or perhaps too neat. They might just be a general screw up, but because they're related to the boss, they can't be fired.

There are a few choices we can make under such circumstances. We can keep stressing out about the person. We can quit our job or ask for a transfer. We can try to change the person's behavior. (Good luck) Or, we can choose to use The Happiness Code to change our own negative reactions and allow us to give a more comfortable response. I vote for the latter.

Spend a moment and visualize or think about the person that bothers you so much. Imagine them looking the way they do, saying things the way they do, doing what ever it is that triggers a defensive reaction in you.

Pay some attention to the type of feelings you get. Is it anger, resentment, disgust, fear, or do you feel intimidated

or insulted? It might be a combination of things. Concentrate on the strongest feeling and go through the Code sequence. Let's say the person's name is Linda. Your setup phrase might be, "Even though I feel this anger about Linda's behavior, I completely love and accept myself."

You may have to repeat the Code sequence a few times to totally dissolve the anger. Now think about or visualize the person again, perhaps in another situation or with another part of their behavior that disturbs you. Once again use the Code and neutralize any upset feelings.

After or even during the process, you may become aware of a person or event in your past that reminds you of the one you just used the Code on. Maybe she looks or sounds just like your mother, sister, classmate or someone else that caused you pain. Such memories may be the root cause of your current discomfort with others. *It may not be the person that is the problem, but what or who they remind you of.*

Use The Happiness code to dissolve any uncomfortable feelings associated with those memories. Once again think of the person you work with. Are there any negative reactions left? If so, go through the Code sequence with each one. Once you've cleared each aspect, you should be feeling quite neutral or even be able to smile when you think of that person.

The Happiness Code can be used everyday – several times a day if necessary – to help us dissolve our anger, fear, resentment, anxiety, or depression in any given situation. But, if our emotional upsets are seated in past issues, unless our past issue is dissolved, we will need to repeat the Code process the next time some similar situation arises. The more we complete our own personal *de-junkification* process the less we will need to use the Code in our daily routines, and we will experience more lasting relief when we do use it.

OPENING THE DOOR TO CHOICE

I had a client that worked as a laborer in a warehouse. He felt down and somewhat depressed about his job. He was always angry with management and resolved to being in what he thought was a dead end job. Like most of the other workers he never put forth more effort than necessary to scrape by. He blamed the company for his misery.

> *After using the Happiness Code to dissolve his past and present anger, his life took on a whole new direction.*

After using the Happiness Code to dissolve his past and present anger, his life took on a whole new direction. He told me that using the Code had opened up a world of choices for him. He now chose to be more positive and productive. When co-workers would sit around and whine about everything, he chose to walk away from the negative talk. He would say, "I choose to be happy." He chose to look for things that needed to be done, and he would do them before someone told him to. If the boss asked him to do something, even if it was asked in a gruff manner, he would smile and say, "Sure." Within just two weeks of taking on his, "I'm in charge of my choices attitude," his work evaluation from his supervisors soared and he was promoted to foreman.

IMPROVING THE BOTTOM LINE

One reason many management and supervisory training programs don't produce better bottom-line results is fear. You can show a person wonderful new methods and ways of doing things, but if they have a fear of change, fear of failure, fear of success, fear of new technology, fear of being disliked, or maybe even a fear that their employees won't do

what they ask, their ability to learn and implement these new methods is greatly reduced.

How many times have we attended a motivational seminar, and afterwards felt like we could go out and take on the world, only to find that when we returned to our familiar work environment, the same old problems and resistance returned with us? It's the same old story. The minute we feel threatened, we return back to our core fears and to our old reactive behaviors. All the "Rah-rah" meetings and seminars in the world, all the dangling of big dollars, all the positive affirmations we can recite, will have no lasting effect until the fear is dissolved and the task now fits within our comfort zone.

Millions of corporate dollars are wasted every year trying to train employees to do things in a manner that goes beyond their comfort zones. Proper use of the Happiness Code in business can boost productivity to much higher levels.

USING THE HAPPINESS CODE TO IMPROVE SALES PERFORMANCE

The number one killer of sales success is fear. The fear of rejection is right at the top of the list. People want to be accepted. It's a basic human survival need. When we hear the word "No" many of us take it personally. We feel assaulted, so our fight or flight reaction takes over.

That's why so many multi-level marketing organizations have such high dropout rates. The new entrepreneurs are uncomfortable trying to sell a product or even an idea to others, even to their own family and friends. Think about it. If I ask my mother, brother, sister, or friend to buy into my new product or venture and they reject me, maybe even ridicule or laugh at me, where does that leave my ego? How

many of us have come home all jazzed up from a "be your own boss and build your own business part time" presentation, only to sit and stare at the phone in fear? We talk ourselves out of calling people by thinking thoughts like, "what if I'm interrupting something important," or "what if they're bothered by my call," or "It's seven o'clock and I'm sure it's too late to call so I'll call tomorrow." Sure you will.

If I were the head of a multi-level marketing company, one of the first training sessions I would offer is how to use the Happiness Code to expand the comfort zone of all my people. If a person suffers from call reluctance, fear is the major cause of the problem. Fear is the major reason people deliver ineffective sales presentations. It's why people do not ask for the sale.

When your sales force becomes comfortable emotionally you will become comfortable financially.

Does someone have trouble building rapport, finding prospects, asking for referrals? Fear is usually a major contributor. Fearful people procrastinate. They quit early in the day or quit sales altogether. Even if a salesperson is fighting through their fear, that will still be projected into the dynamic of their sales presentation. The potential customer will be negatively influenced by the salesperson's underlying fear and may not even know why. Once again I believe that The Happiness Code should be the first thing taught in any sales course. When your sales force becomes comfortable emotionally you will become comfortable financially.

Any business owner, manager, sales manager, human resources director, or personnel manager who cares about employee productivity should expose their managers and employees to "Comfort Zone Training" and to the proper use of The Happiness Code.

Future fear –
Dissolving the "What Ifs"

It is incredible how mush time we spend stressing about the future. What if this happens? What if that happens? As I said before, I call this "Pre-traumatic Stress." What we are worried about hasn't even happened and we are reacting as if it had. Research has shown that only about five percent of the things we worry about actually happen. Think of the energy drain and stress we put ourselves through by worrying about things that have a ninety five percent chance of never happening. Besides, we usually manage to handle the things that do happen, and often, everything winds up better for it.

Research has shown that only about five percent of the things we worry about actually happen.

It seems silly that the "what if" syndrome causes more stress than the "what is." So why worry about it? If the company we work for might be sold, will our stress and worry about it change anything? Will stressing out over the possibility of getting a new department head help us or anyone else? Will worry about whether or not we will pass a test improve our test scores? Will stress about whether the boss will like our presentation make a positive difference in our performance? Of course, the answer is no. In fact it just adds to the problem.

So why put ourselves through all that emotional pain and anxiety, when we can use The Happiness Code to comfortably dissolve it? Using the Code to dissolve anxiety about an upcoming medical procedure will not only help us through it, but it may also help us heal faster.

Being free of the anxiety allows us to more comfortably adapt to any situation. We can make clearer and more productive business and personal decisions. They will be based on reality instead of emotional reactions. There is a school of thought that believes we manifest the things we focus on in our lives. If we focus on our fear, we bring that which we fear into our lives. You know, self-fulfilled prophecies and all that. Besides, it just stands to reason that if our thought patterns are more comfortable, our life will be more comfortable.

Keep in mind that most of the anxieties we feel about the future, are products of our past. So the more personal de-junkification we do, the less anxiety we will have about future possibilities. We will be more confident in our ability to handle whatever challenges come our way.

DISSOLVING FUTURE FEARS – THE METHOD

Think of what it is you're worried about and use the Code to dissolve your anxiety. Your setup phrase (while touching the #1 spot) could be, **"Even though I have this anxiety about** (state what you're anxious about), **I totally love and accept myself."** Then while thinking of what you are anxious about touch the remaining points in the order shown on the following page. Remember to hold each touch for about 4 or 5 seconds.

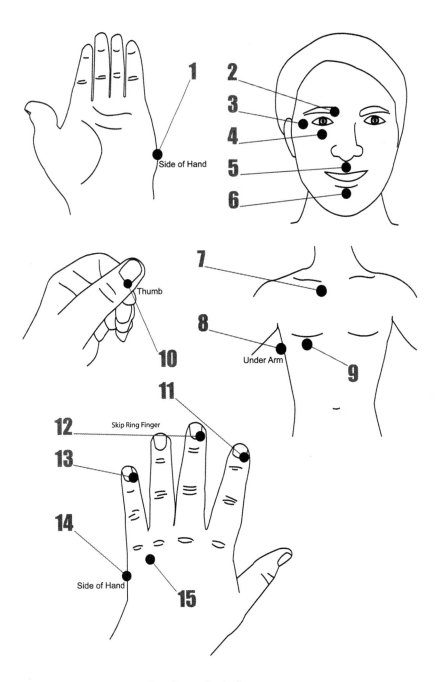

The Happiness Code Sequence

(Note: Touching point #9 may be omitted most of the time. If you don't get relief then put #9 back into the sequence and try again. Point #9 is located one inch below the nipple on a man. For women it is where the under skin of the breast meets the chest.)

Now continue touching the #15 spot while you:

 a. Close your eyes and open them again;

 b. Move your eyes down and to the right and then down and to the left;

 c. (Still touching #15) Whirl your eyes in a complete circle;

 d. Whirl your eyes in the other direction;

 e. Stop eye movement, but keep touching #15 and hum a 5-second tune;

 f. Count to five out loud (1-2-3-4-5);

 g. Hum a tune again.

Again access the thought that was bothering you when you first started the sequence. The upset should be gone or lower. Feelings about the past issue should be more comfortable.

If the feelings are better but not completely comfortable, refocus on the problem thought and repeat the process.

Do not try to think positive or try to push the bad feelings away during the process. The upset feelings will dissolve on their own. It is not a distraction technique. If it was, the problem would pop back the minute you thought about it again. As long as you have dissolved the core issue driving the bad feelings, it won't.

Happiness Code Helps

USING THE CODE TO DISSOLVE PHYSICAL DISCOMFORT

The Happiness Code can sometimes help to reduce or even eliminate some physical discomforts, including inhalant-type allergy reactions. I have seen it used for headaches, even migraines, with amazing results. Since most physical pain also has an emotional element, body pain sometimes disappears as a welcome side-effect when an emotional issue has been dissolved. I have seen this especially evident in chronic headaches and also in neck, shoulder, or back pain. I have even seen the Code reduce the pain of sprains and broken bones.

Note: Of course if you are experiencing physical pain, it can be a prime indicator of a medical problem, so you should also consult with your doctor or medical professional.

There are a couple of ways to work with physical pain. The first way is to focus on the pain itself. Gauge the amount of pain on a scale of one to ten. Ten would be the worst pain imaginable and one being no pain at all. While using two fingers to touch the #1 spot on your hand, say a set up phrase that describes the pain, such as, "Even though I have this stabbing pain in my back, I completely accept myself" or you might say something like, "Even though I have this throbbing headache behind my eyes" or "Even though I have this dull ache in my right knee, I completely

accept myself." Then while thinking of the pain you feel at the location you described go through the Code sequence.

The second way is to focus on *how you feel* about the pain – the anxiety or worry it is causing you. Your setup phrase might be, "Even though I'm afraid this pain in my back will never go away, I completely accept myself" or "Even though I'm afraid I may lose my job if I have this pain, I completely accept myself." Then go through the Code sequence while thinking about your particular worry. In many cases the use of both methods, one following the other, is recommended.

USING THE CODE FOR SPORTS ENHANCEMENT

Anxiety can be a huge block to our success in any sport. There is a big difference between being excited and being nervous. Being nervous usually tightens all the wrong muscles and sends self-fulfilling thoughts of disaster through our mind. The more we worry about doing poorly, the better chance we have of doing just that. Using The Happiness Code to eliminate sports anxiety is like having your own fairy godmother helping you every step of the way.

Being nervous usually tightens all the wrong muscles and sends self-fulfilling thoughts of disaster through our mind.

I use it in my golf game all the time. I use it to completely eliminate first tee jitters, or take away any fear I have of hitting a bad shot or hitting a ball into the water. Oh, it still happens from time to time, but not nearly as often. And when it does, it is certainly not because I was worried about it happening. While on the course, I usually use a shortened version of the Code sequence, basically just using spots one through eight. That seems to work just fine.

Having less fear in my life has raised my enjoyment of my golf game in other interesting ways. Sometimes during a golf match, we don't just root for ourselves; we root *against* the other players. In our desire to win, we hope our shots will be great and theirs will be – well – not so great. While the other player is putting, we might be thinking, "miss it, miss it!" Awhile back while playing a golf match during league play, I made the decision to root for everyone. That's right, not just for myself, but for the other players as well. I took the attitude of hoping we would all do well on each shot. It was wonderful! I not only enjoyed my good shots, but I enjoyed their shots also. I got four times the enjoyment. There was no negative energy.

I once had some concerned parents bring their sixteen-year-old athlete son to me. He was a runner on his high school cross-country team. He would have such anxiety on race day that he would throw up during the race. Not before or after, but during the race. It would never happen during practice, not even during all out hard practice runs.

I taught him the Code and we used it to end any anxiety he had about it happening again, and also to eliminate any worry of how well he would do in a race. He used it again just before his next race. His father called to let me know that the problem was totally gone.

Yes, using the Happiness Code can improve performance and enjoyment in any sport.

WHAT IF IT DOESN'T SEEM TO BE WORKING FOR ME?

The reason I could make the challenge I did at the beginning of this book – "before you buy this book" – is because even for a person newly introduced to the Happiness Code, their chance of success using it is a little more than 80%. This is actually an extraordinary success

ratio. Not many other techniques can make such a claim. However, when a hard case comes along, and using the Happiness Code doesn't seem to be making much difference, there are a few things that can be done to increase success to even higher levels.

If you've tried the Happiness Code without success and you know you have addressed all aspects of the issue, *and* you were focused on the *problem* thought, not the solution, in other words, you weren't trying to push the bad feelings away with positive thinking, then a possible cause of such a block may be some form of energy toxin or in some cases simple dehydration.

Most of us don't drink enough water throughout the day. Plus, water can help flush or dilute other energy toxins from our system. I have seen difficult cases become normal just by drinking a couple glasses of water and then applying the Code sequence once again.

Some people are more sensitive to the chemical toxins around them than others. Remember the experiment I asked you to try in the beginning of this book demonstrating the toxic reaction that most people have to the chemicals in artificial sweeteners? We drink diet drinks that are nothing more than chemical time bombs to our energy system. But, it's not just the chemicals we ingest that cause problems.

In the world we live in today, we are all surrounded by natural and chemical toxins of all types. Our foods are laden with dyes, preservatives, and a variety of pesticides. Heck, our underarm deodorant has more chemicals in it than we can pronounce. Make-up, hairspray, perfume, and shampoo all have chemicals in them. And the list goes on and on. For some people, wheat bread is a toxin. I know of a case where a woman had battled depression for many years. She used Prozac and a host of other drugs, but they only masked the problem. She eventually discovered that she had sensitivity

to wheat, and after eliminating wheat from her diet her depression lifted entirely.

Even the clothes we wear can be toxic to our energy system. The chemicals they've been treated with, the laundry soap we use to wash them, the dry cleaning chemicals in them, or the fabrics themselves may act as toxins to our energy system. I've had clients that weren't responding normally to the Code and the simple act of taking off the jacket or sweater they were wearing made everything change to normal.

Even the clothes we wear can be toxic to our energy system.

Our bodies can usually ward off the effects of toxins, but sometimes they begin to pile up and finally, that one extra toxic substance puts us over the top. If I'm wondering about whether something is toxic to me, I sometimes do a muscle test to find out. If I hold the substance, let's say a bottle of cologne, or maybe a piece of wheat bread, close to my chest (solar plexus) and extend the other arm straight out sideways, and then have someone push down on my extended arm, if the arm tests weak then the substance is not good for my energy system and should be avoided.

Sometimes we just have to become detectives to find the toxic culprit. It might be something in our immediate environment that is causing the problem. It could be an electronic device such as a television or a computer. Paint fumes, carpet, ventilation system pollutants, perhaps even the chair you're sitting in can be toxic. Try moving to a different room or even outside, and then try The Happiness Code again. The key to success with a toxin problem is persistence. You may have to get naked (hopefully at home) and possibly take a bath or shower without soap.

Remember that a substance that is toxic to one person's energy system may not be toxic to someone else.

Alternatively, some things actually considered healthy to most people might be toxic to us. I've seen situations where lettuce triggered a toxic response.

The good news is that The Happiness Code will work for most of us even if we are experiencing toxins in our environment. In fact, I've even seen it dissolve the effects of an allergic reaction. For example, using the set up phrase, "even though I'm allergic to my cat" followed by the Code sequence may dissolve the allergic reaction. It's worth experimenting.

INCREASING OUR SPIRITUAL AWARENESS

My own view of what being a spiritual person means, is being a person who is doing their best to recognize and respect the God in all things. It isn't about thinking we are better than anyone else. It is about seeing others as well as ourselves as the connected pieces of divinity that we are – beings of love and light, with unlimited creative potential.

Life is all a gift or a burden and we are the ones that decide which. We can seek truth beyond tradition and create a state of cooperation instead of competition. In my studies for my Ph.D. in comparative religion, it became increasingly evident that with all the great religions of the world, when we *listen* to the message instead of getting caught up in the messenger, each one stated similar things. They said the equivalent of *love others as you would love yourself* – not just when others are doing what we want them to, but all the time. It's easy to be spiritual when things are going along great. The true test, however, is what happens when things get tough.

We need to make a choice. We can choose a loop of fear or a loop of love. We can choose to be who we are

and what we feel. We can stop the insanity that separates us from God and each other, not by trying to change others, but by changing ourselves. The Happiness Code is that doorway to choice.

SOME FINAL THOUGHTS

We can use the new and evolving technology of the day to facilitate deeper conflict between ideologies in the world, or we can seek new directions of understanding, tolerance, and even a celebration of our differences. People of a like mindset can have a wide influence among a larger group of people. The choices we make will have far-ranging effects.

Changes can cause immediate discomfort, even chaos. However in the big picture, chaos can be beneficial. It can be the vehicle for positive outcomes. We can move to something better than we enjoy right now. So embracing change is not only important, but being able to embrace change in a frame of positive contribution (that means with a lack of fear, both past and future) can be ultimately beneficial to us all.

With fear prominent in our life, the recipe we create for the future can be filled with more conflict and misery. Without fear, we create a future filled with cooperation and mutual growth.

We are going through the greatest human metamorphosis in the history of the world. How we approach it is vital. We can acknowledge it and prepare ourselves to be a part of it. If we do this, the changes around us can be beautiful, exciting, thrilling, and fulfilling. Transcending fear is part of moving from the ordinary to the extraordinary. Expanding our comfort zone is expanding our possibilities. It's living with passion, not drama, finding balance and wholeness.

There is no better time than right now to be happy. Happiness is a journey, not a destination. So work like you don't need money. Love like you've never been hurt, and dance like no one's watching. As the song says, "Let there be peace on earth and let it begin with me."

Remember you are not alone. I would like to hear from you. Let me know how you have used the Happiness Code to make your world a better place to live in.

Love and light,
Gary L. Laundre, Ph.D.

For more information about Dr. Laundre, bringing *Comfort Zone Training* to your company or organization, or for other resources please visit our website:

WWW.THEHAPPINESSCODE.COM

How have you used the Happiness Code to help you in work situations, family, sports, relationships, spiritual life, or any other way?

Gary would enjoy reading about your experiences via email at

GARY@THEHAPPINESSCODE.COM

Some of these experiences may be posted on our website if you give permission to do so.

BOOKS BY GARY L. LAUNDRE

THINK AND GROW THIN
> The Easy Weight-Release Method!
> 1993

HOW TO EXPAND YOUR COMFORT ZONE
> Release the Fear that Holds You Back!
> 2001

THE HAPPINESS CODE
> The Amazing New Science of Creating
> Our Ultimate Emotional Comfort Zone!
> 2007

Index

About the Author

Gary Lee Laundre was born in Detroit, Michigan in April, 1947. He served as a Navy Air Crewman in electronic countermeasures in Vietnam from 1965 - 1969. Upon his return home, he earned his degree at Michigan State University in Radio & Television Broadcasting and was hired quickly by WILS, in Lansing, Michigan. Gary Laundre became immediately successful as a radio and television personality and reached millions of people in broadcasts.

During the 1970s, Gary became a noted stand-up comedian. His comedy routine dealt boldly with many major issues of the day, including sexism and racism – issues that many others were afraid to touch. Gary's brand of humor brought his audiences to a higher plateau of understanding while leaving them rolling with laughter.

After being published in several national magazines and gaining further momentum in the entertainment industry, Gary was recognized by the world-famous Statler Brothers and spent the next six years touring with them as their opening comedy act.

In the early 1980's, Gary began formal writing activities as a professional screenwriter. He wrote the screenplay for "Madagh – The Sacrifice" through which he hoped to make the world aware of the Armenian Holocaust suffered in 1915.

In 1983 Gary Laundre earned his doctorate in Transpersonal Psychology and Comparative Religion. While at the same time, he served as an English teacher at southern California's Hollywood Academy, helping newcomers to America become well acquainted with the English language.

His interest in helping people overcome personal challenges continued in other ways. Gary began work on his own manuscript for a book that would eventually change the way thousands of people deal with their eating habits. The result is the highly acclaimed book, "Think & Grow Thin," published in 1994.

By this time, Gary Laundre was settled in Grand Rapids, Michigan, where he developed a successful behavioral therapy practice. Here, he personally helped thousands of clients to lose weight, stop smoking, and successfully deal with phobias, fears, and anxiety issues. Gary's techniques focus on both the mind and the body working together as a team to produce the best results. His dedication to quality has produced a steady stream of professional and private referrals to his practice over the last quarter century.

Gary Laundre's dedication to the community and its health has prompted a steady stream of radio interviews, television specials and magazine articles internationally. As

past president of the International Association of Therapeutic Specialists, (a non-profit organization) Dr. Gary Laundre helped to pioneer efforts to integrate varied healing techniques into mainstream medicine.

His internet column, "Health Reviews by Dr. Gary Laundre" helped serve as a conduit to his international audience. It offered his readership a means and a guide to find the highest quality and most effective solutions available in the health industry.

In 2001, Dr. Gary Laundre authored a new book, "How to Expand Your Comfort Zone – Release the Fear That Holds You Back." This book has helped thousands of people to become aware of the strength and resiliency of the mind-body system to release fear, anxiety, and other issues in order to live a more comfortable life. Dr. Laundre's newest book, "The Happiness Code," is a culmination of 25 years of his work to help people to help themselves live a better, happier life.

Dr. Laundre continues to live and work as a behavioral therapist in Grand Rapids, Michigan at the American Institute, which he founded. He travels extensively throughout the United States providing workshops on many college campuses while demonstrating the powerful capabilities of the human mind.

"Find a way to be of service."

De-Junkification Diary

As described by Dr. Laundre in this book, this section is provided for you to keep a journal of your own experiences dissolving fears, phobias, self-limiting conflicts, and anxieties. Thank you for sharing your experiences with us.

De-Junkification Diary

De-Junkification Diary

De-Junkification Diary

De-Junkification Diary

De-Junkification Diary

De-Junkification Diary

De-Junkification Diary

"Peace does not mean to be in a place where there is no noise, no trouble or no hard work, it means to be in the midst of those things and still be calm and secure in our heart."

WHAT PEOPLE SAY ABOUT THE HAPPINESS CODE AND THE PROCESS OF RELEASING FEARS...

"The Happiness Code has cleared my thinking, helped me restore relationships, and opened the way to even greater prosperity in my life. It's simple and brilliant!"

— Dirk A., Success Coach, Speaker

"Dr. Laundre's book has been of great help to me, my family, co-workers and friends. His fear-release method is easy, relaxing, and it is very effective. I purchase his books as gifts for the people I care most about."

— Karen H., Mother, Grandmother, Missionary

"Before Mind Tuning I was so upset about a broken relationship that I couldn't concentrate on my work or anything else. These techniques put me instantly back on track. Thank you so much!"

— Lynn P., Product Designer

"Before you showed me this method, the stress and anxiety of meetings and presentations with major clients was becoming unbearable. Now it's as if I can breathe again!"

— James E., Chief Executive Officer